IMAGES
of America

BEND

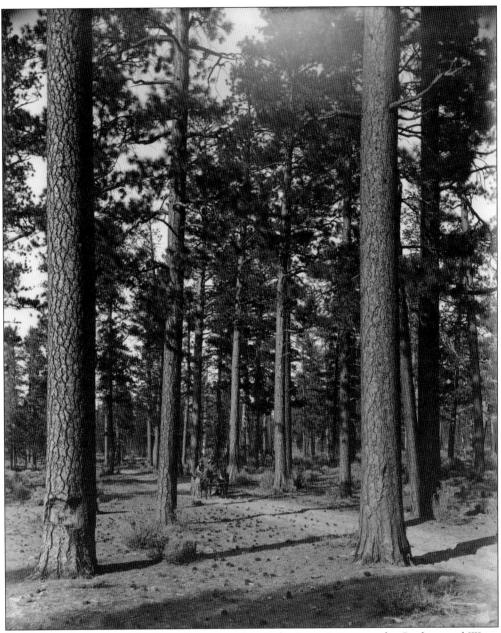

In 1905, geologist Israel C. Russell wrote in his *Preliminary Report on the Geology and Water Resources of Central Oregon*, U.S. Geological Survey, "[The] yellow pine forests [in the] central part of Oregon are not only extensive but contain magnificent, well-grown trees, which will be of great commercial value when railroads . . . bring them within reach of markets."

ON THE COVER: Two men drive a wagon through the magnificent ponderosa pine forest near Bend, Oregon, in this early-20th-century photograph.

IMAGES
of America

BEND

Deschutes County Historical Society

ARCADIA
PUBLISHING

Copyright © 2009 by Deschutes County Historical Society
ISBN 978-0-7385-7184-3

Published by Arcadia Publishing
Charleston, South Carolina

Printed in the United States of America

Library of Congress Control Number: 2009926441

For all general information contact Arcadia Publishing at:
Telephone 843-853-2070
Fax 843-853-0044
E-mail sales@arcadiapublishing.com
For customer service and orders:
Toll-Free 1-888-313-2665

Visit us on the Internet at www.arcadiapublishing.com

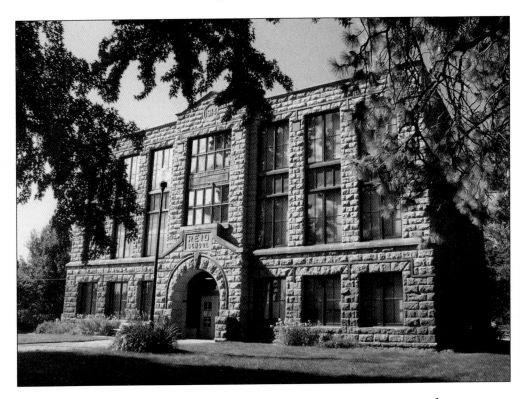

*To the members of the Deschutes County Historical
Society whose dedicated preservation and interpretation of
Deschutes County's history has inspired, is inspiring, and
will continue to inspire Central Oregon's citizens.*

CONTENTS

ACKNOWLEDGMENTS

Few members of the Deschutes County Historical Society's Centennial Book Committee who compiled *Bend: 100 Years of History*—the predecessor of this volume published by the society to mark Bend, Oregon's, centennial year—knew the effort that would be required to "just put some of the Deschutes County Historical Society's photos together for a centennial book." Although the museum had thousands of historic images, sorting through them to select the best ones, and preparing captions for each, proved a tedious task, as did the revisions to publish this book.

The original committee did an outstanding job. The book they produced, now out of print, reflected the development and diversity of Bend, tied together with great photographs and text. A few members of that committee must be recognized. One of the most dedicated was Donna Meddish, a talented writer with a critical eye for accuracy in recording historical events, who was a consistent contributor from the beginning. Alongside Donna worked Sue Frewing, the former Conservator, Exhibits, and Collections manager at the museum, who focused on structuring the chapters and researching the captions. The contributions of John and Jean Frye were essential; without them, the original centennial book would not have been completed. Other contributors included Ward Tonsfeldt, for production of chapter one, the chapter introductions, and valuable historical perspective; Bill Boyd, for early street names and the market road research; Gail Carbiener, for scanning historical photographs to produce high-quality digital images; and Ed O'Rourke, of Art Resources Technology, for digital scans of several photographs, maps, and newspapers. Curt Lantz, then museum manager, chaired the committee.

Those who followed in the footsteps of the original committee to produce the current Images of America version benefited immeasurably from the experience, as well as the product, of those who preceded them. Kelly Cannon-Miller, the executive director of the Deschutes County Historical Society, and Les Joslin, president of the board of directors (2007–2009), led the revision effort that incorporated photographs and information unavailable to the producing committee of the original book. Brandy Philip edited the photographs.

Unless otherwise noted, images are courtesy of the Des Chutes Historical Museum, which is operated by the Deschutes County Historical Society.

INTRODUCTION

Bend the Beautiful! What was it that brought the early settlers to Bend? Once railroad travel and then modern highways made Bend more accessible, what drew people to Bend?

The following passage from a 1911 promotional publication entitled, *The Bend Book*, suggests why Bend continues to attract so many. These prophetic words are attributed to William D. Cheney, who came from Seattle to found the Bend Park Company, one of the West's first big land development companies:

> From the top of Pilot Butte we look off to the east, and stretching away as far as the eye can reach, we see level farm land, all irrigated, with here and there white specks that are houses and green squares that are farms. We remember that we have just come from the north through twenty miles of irrigation. We now see irrigation clear to the horizon—northeast, east and southeast. We know that back of us lie countless miles of virgin forest—forests of pine at that, the wood fast becoming so rare—and we realize that we are standing at the geographical center of a country so rich in resource that a city, not a town, but a *city*, must some day be built here, even if there now proves to be no town at all. Then we turn to the west, climb to the crest of the hill—and before us, beside a river, in the midst of a natural park, with snow-capped mountains shining in almost constant sunlight, with air like wine, three thousand six hundred feet above the sea, is Bend. Behind and on both sides of us, the irrigated farms of Wenatchee. Surrounding them, the wheat lands of Minnesota. Before us, the pine lands of Michigan and the power of Niagara. On all sides of us, the scenery of Switzerland.
>
> In the center of this setting, a town, having the altitude of Colorado, the cool summers of Seattle, and a winter climate unlike any other in the world—almost snowless, with clear cold nights and sunny days too warm for furs. Just think of being able to say these things truthfully about any town. It seems as if we were about to enter an immense city instead of a village of six hundred people.

There were four major events that helped Bend transform from the small frontier village Cheney mentioned, to his vision of the bustling city it is today. First, construction of irrigation canals during the early 1900s added family farm–based agriculture to ranching, making Bend an even more desirable place to live. The second event was the arrival of the Oregon Trunk Railroad in 1911, providing Bend's agricultural products and timber resources access to outside markets, encouraging rapid development. Thirdly, sawmill operations sprang up, and in 1916 when two giant lumber companies—Shevlin-Hixon and Brooks-Scanlon—began operations, Bend's image as a timber town was born. Lastly, long before Bend lost its mill town identity, recreation and tourism became major forces behind its growth and development.

To mark Bend's centennial, a committee of Deschutes County Historical Society staff members and volunteers compiled and published *Bend: 100 Years of History* in 2005. This collection of captioned photographs depicted, in era-based chapters, the life and times of Bend's first 100 years as an incorporated city—as well as the several decades that led up to that incorporation. As was the case with that volume, the current book is not intended as a comprehensive history of Bend; rather, it is a revised kaleidoscope of images and anecdotes that represent the city's 100-plus years of history. These evoke memories for those who have been part of that history and help more recent arrivals and visitors understand what made Bend the city it is today. The focus on the early times, from initial settlement to World War II, that characterizes the society's collection—perhaps because more recent decades are not yet viewed as "historical" years—is reflected in this book.

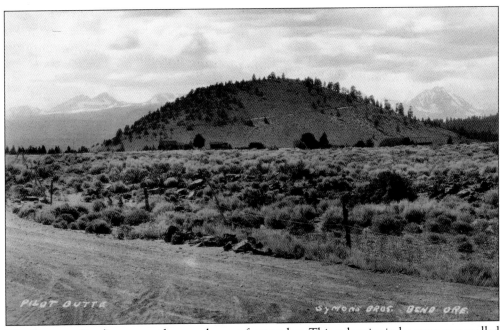

Pilot Butte, on Bend's eastern side, was a beacon for travelers. This volcanic cinder cone, once called Red Butte and then Pilot Knob, was mentioned as "Pilot Butte by the River" in an 1853 Elliott Wagon Train diary. By the early 1860s, when military wagon trains traveled the Huntington Wagon Road between The Dalles and Klamath Falls, the name Pilot Butte was entrenched and travelers used it to locate the crossing site on the Deschutes River that became the city of Bend.

One

A PLACE OF PROMISE
BEFORE 1905

The upper Deschutes River country appealed to Native Americans long before Euro-Americans settled there. Evidence of habitation at Fort Rock dates back 11,500 years; within the Newberry Caldera, it dates back 10,500 years; and near Odell Lake, it dates back 9,500 years.

After the Mount Mazama eruption, some 7,700 years ago, hunters and gatherers visited central Oregon. Game could be found during part of the year, but edible plants were not abundant. Areas farther south, in the Klamath Basin, and farther north, on the Columbia River, offered better opportunities for permanent habitation. Over the past 2,000 years, modern native groups, including the Tenino/Tygh (Warm Springs Bands), Mollola, Klamath/Modoc, and especially the Northern Paiute, visited the upper Deschutes Basin.

In the first decades of the 19th century, fur trappers from the Hudson's Bay Company visited the Bend area that is evidenced by a rock, inscribed with the date 1813, found on a bank of the Deschutes River. Peter Skene Ogden, Hudson's Bay Company trapper, visited in December 1825. Nathaniel Wyeth passed through in 1834, and John C. Fremont's expedition visited in 1843. In 1845, Stephen Meek led immigrants through the area in an ill-considered attempt to find a direct route from the Snake River to the Willamette Valley.

The first Euro-American settlers entered the Bend area in the 1870s. Records of early homestead filings are murky, but a Thomas Geer filed on and patented a land claim that he sold to John Young Todd in 1877. Todd named this the Farewell Bend Ranch, for which Bend was named. Todd was a fabulous frontier character, who went west from Missouri to serve in the Mexican War.

Todd sold his ranch to John Sisemore in 1881 and Sisemore applied for a post office in 1886. Because the name Farewell Bend had been taken, postal authorities shortened it to Bend. Other settlers in the 1880s included William Staats and Marshall Aubrey. In 1900 L. S. Weist and A. M. Drake came to Bend. They were developers, interested in buying land for resale to future settlers. Drakes' Pilot Butte Development Company provided the first irrigation water to the town.

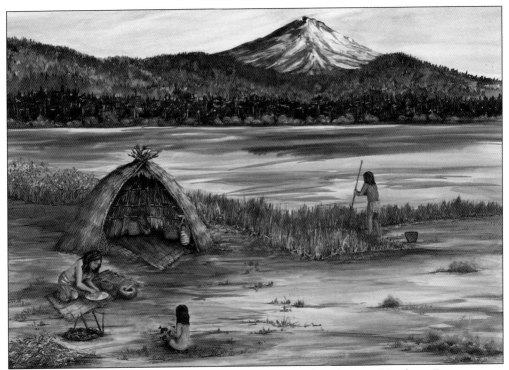

For many centuries before Euro-American exploration and settlement, Northern Paiute groups from the arid sagebrush steppes to the east visited the upper Deschutes River country each year as part of their "seasonal round." Following seasonal opportunities for hunting and gathering, they camped along the Deschutes River and on the banks of a long lake that filled part of the basin after the lava flow from the Lava Butte eruption dammed the river at what is now Benham Falls. These visits allowed them to make the best use of animal and plant foods that the upper Deschutes area offered. (Above, courtesy of Sunriver Nature Center.)

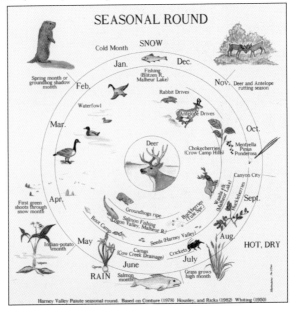

Fur trappers and explorers preceded settlers. The date 1813 carved in a boulder found south of Bend indicates when the first Euro-Americans arrived in the vicinity. From 1813 until 1835, fur trappers from the John Jacob Astor Company at Astoria and the Hudson Bay Company at Fort Vancouver searched for beaver along Central Oregon's waterways. Peter Skene Ogden (right) of the latter company sent and led parties through the upper Deschutes country in the late 1820s. Explorers included Lt. John Charles Fremont (below), U.S. Army Corps of Topographical Engineers, whose 1843 expedition, which passed through on the way from The Dalles to California, included scouts Christopher "Kit" Carson, Thomas "Broken Hand" Fitzpatrick, and Warm Springs tribesman Billy Chinook.

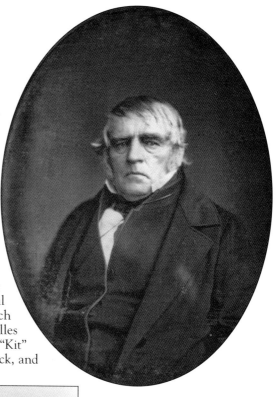

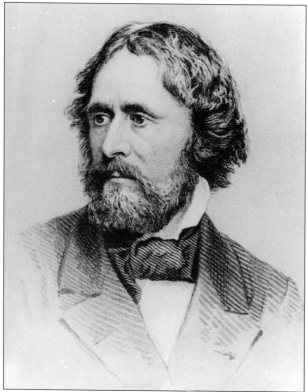

Immigrants to Oregon's lush Willamette Valley followed. In 1845, trapper Stephen Meek convinced 200 wagons that crossing Oregon's desert would shorten the trip. After leaving Fort Boise, the wagon train followed the Malheur River westward but became lost. Water and feed for the animals was lacking. Many became sick and died. After finding water in the Crooked River Basin, the train split. Many wagons went northwest to Fort Dalles. Others went westward toward the Deschutes River before giving up Meek's route and heading north to Fort Dalles. In 1949, woodcutters found a large juniper tree northeast of Pilot Butte with the inscription "1845 Lost Meeks" carved on one of its large bare limbs—perhaps a message left by Meek's lost wagon train before it found its way to safety. (At left, courtesy of Oregon Historical Society.)

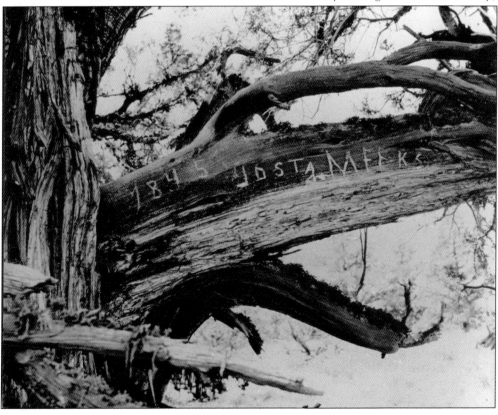

Early settlers in the upper Deschutes country were cattle ranchers. Among the more colorful was John Y. Todd, who came to Oregon in 1852 and ran a pack string from Jacksonville to Portland. In 1846, Todd married 16-year-old Mary Hannah Campbell and settled in the Tygh Valley. That year, he went into the cattle business with Jim Odle and Alf Orton and established the "OTO" brand. The three drove probably the first herd over the Cascade Range into Central Oregon. Todd built Sherer's Bridge in 1860 and rebuilt it in 1862 after floodwaters swept it away. In 1887, he bought the Farewell Bend Ranch—on the banks of the Deschutes River in what is now Bend's southern section—for $60 and two saddle horses. Todd Lake, about 20 miles west of Bend, was named for this Central Oregon pioneer.

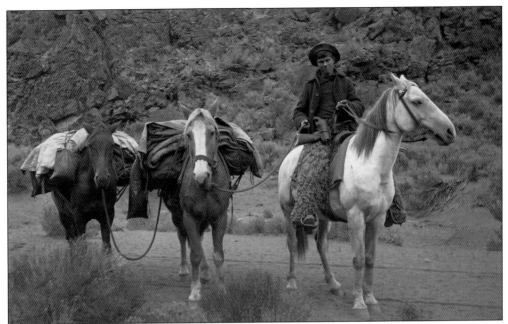

Immigrants and settlers depended on horsepower. This young buckaroo is leading packhorses loaded with supplies. The hanging bags were filled with water. The buckaroo is wearing angora chaps, leg coverings made from goat hair, for warmth and safety. He has a rifle across his lap and a holstered pistol on his belt.

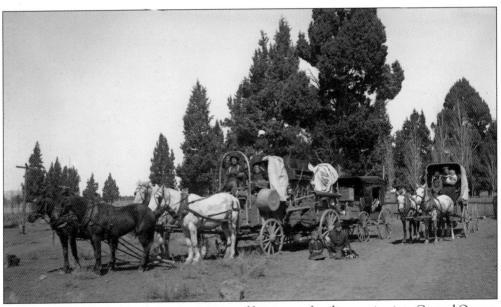

This was a common mode of transportation used by pioneer families moving into Central Oregon and, after the railroad reached Bend in 1911, within the region. In order to bring all the belongings necessary for settlement, the lead wagon has the family buggy in tow.

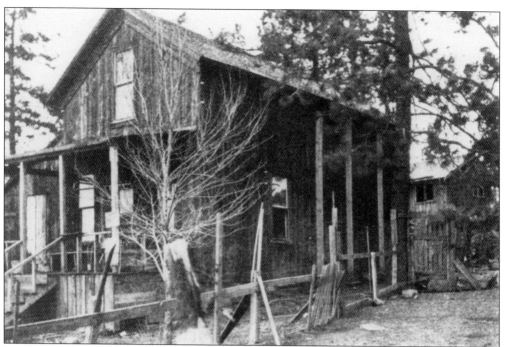

Bend began in the 1880s as a small cluster of settlers' houses in the Farewell Bend Ranch vicinity on the Deschutes River. One, the William Staats house, was just north of today's Colorado Avenue Bridge on the east side of the river. A post office was established in 1886 at the Sisemore place where the Old Mill District now stands. Staats became postmaster in 1889 and moved the post office to his house.

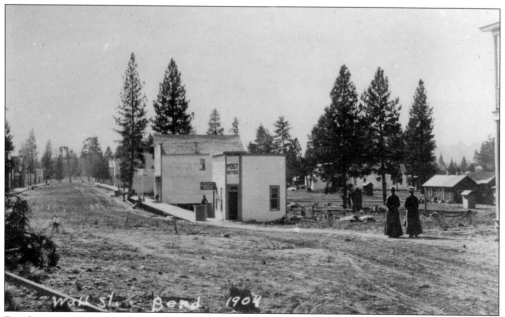

Bend's post office was relocated from the William Staats house to the southwest corner of Wall Street and Newport Avenue in 1904. The post office was officially named Bend because there already was a Farewell Bend post office on the Snake River in eastern Oregon.

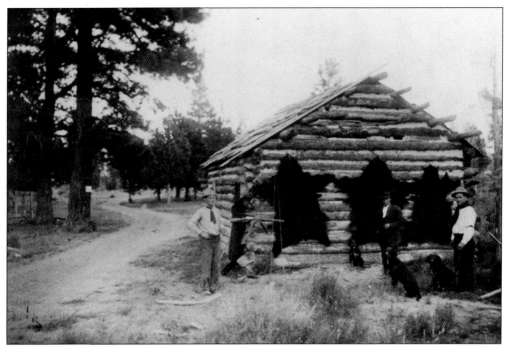

Bend's first schoolhouse was a log cabin on Steven Staats' property beside the Deschutes River in today's Drake Park. The cabin served as a school, community center, church, and Sunday school from 1883 to 1903. In 1903, the school moved to a new building on Wall Street and the cabin became the first home of the then-weekly *Bend Bulletin*. In this 1900 photograph, locals show off bear hides on the schoolhouse.

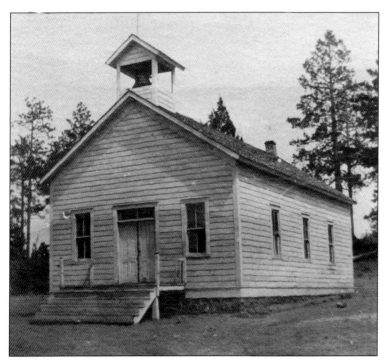

Bend's second schoolhouse, a wood-frame structure built at the convergence of Wall and Bond Streets, opened in 1903. Within a year, overcrowding required hiring two additional teachers and renting space in downtown buildings.

Ruth Reid, on the right, who came to Bend in 1904 from New Brunswick, Canada, taught in Bend's small second schoolhouse and served as principal. After the regular school day, she taught the first high school classes that led to Bend High School's first graduating class of four students in 1909. Pearl Hightower is on the left.

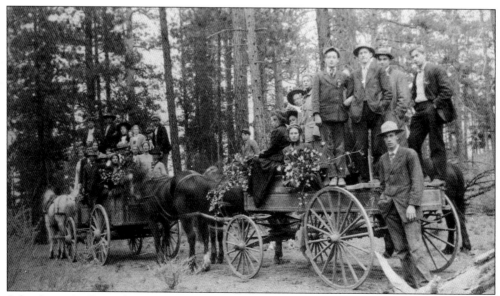

School wasn't all "readin', writin', and 'rithmetic." Bend's beautiful surroundings invited such adventures as this seventh- and eighth-grade school picnic in 1910.

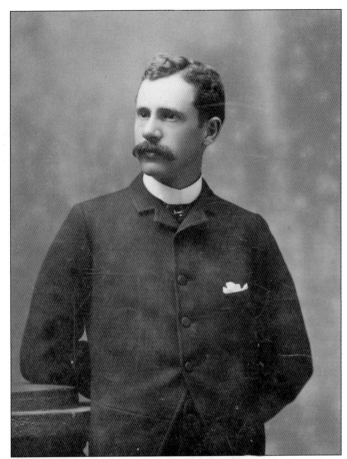

In 1900, Midwestern businessman Alexander M. Drake and his wife, Florence Drake, searching for a healthy place to live, halted their covered wagon to camp at the edge of the Deschutes River. Drake founded the Pilot Butte Development Company to irrigate arid lands near Bend, and the couple built a fine log home that soon became a center of Bend social and civic life. The rock wall on the east side of their extensive lawn gave Wall Street its name. Their log house was later home to Bend's early Emblem Club boosters and then became the meeting place of the local Masonic orders.

Clyde McKay came to the upper Deschutes country in 1900 as a young timber cruiser. He helped consolidate the timber holdings that led to the establishment of the lumber industry in Bend and played other key roles in the development of the city. An avid outdoorsman, McKay was active in improving hunting and fishing and once served as the State of Oregon game warden in the area.

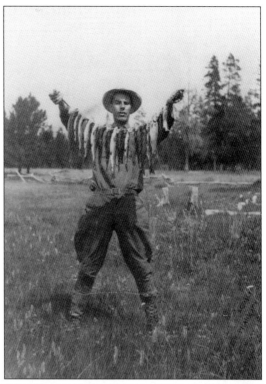

McKay married Olive Spencer in Minnesota in 1906 and built this house on a Mirror Pond lot near downtown Bend in 1916. Their sons, Duncan and Gordon, grew up in this house. Duncan McKay was a Bend attorney, and Gordon McKay was an associate in his father's Deschutes Title and Abstract Company, who also served as an Oregon state senator. The house, moved to O. B. Riley Road during the 1980s, is now a restaurant.

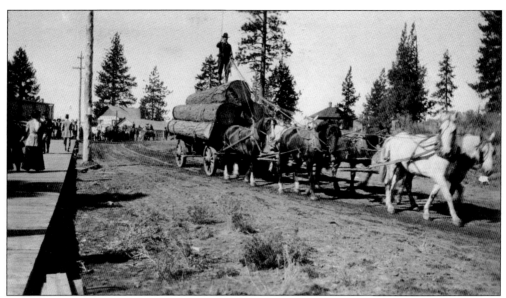

Building the town of Bend required construction materials. This six-horse team pulls a wagon loaded with ponderosa pine logs along a downtown street to the Bend Company sawmill.

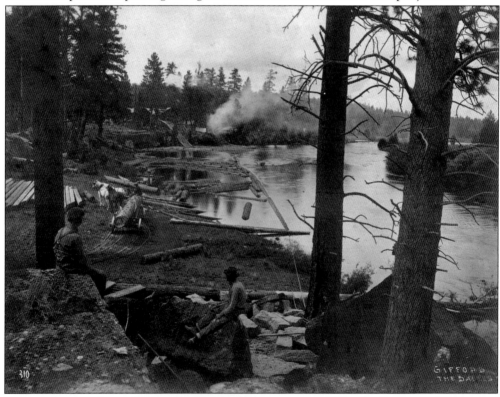

This stone quarry, located on the Deschutes River near today's Columbia Park, was the source of a comparatively soft volcanic tuff used as a building stone. Many structures in Bend and Central Oregon, including the railroad depots in Bend and Redmond and the Reid School in Bend, were built of this tuff. The Bend Company sawmill is in the background.

Two

GROWTH BEGINS
1905–1910

Bend was incorporated in 1905. This enabled the community to form a city government, levy taxes, and hold municipal elections. Irrigation and development were the biggest businesses. Lands irrigated by Carey Act of 1894 projects were available, as were tracts under several homestead acts and Timber and Stone Act of 1878 parcels. Most of these opportunities for free land were managed by the General Land Office of the U.S. Department of the Interior. Bend's land office did a brisk business.

The same year saw the beginning of the U.S. Forest Service. Since 1891, huge tracts of public land in the West had been set aside as forest reserves, managed by the Department of the Interior. Bend was between the Cascade Range Forest Reserve to the west and the Blue Mountain Forest Reserve to the east. In 1905, the forest reserves were transferred to the new Forest Service in the U.S. Department of Agriculture and in 1907 renamed national forests. Bend became headquarters for the Deschutes National Forest.

In his 1939 book, *Frontier Doctor*, Urling C. Coe described a 1905 Bend street scene:

> Freighters, stockmen, buckaroos, sheep herders, timber cruisers, gamblers, and transients of all kinds who had been attracted to the town by the boom, thronged the bars or played at the gambling games, and the stores were doing a rushing business. The stores remained open in the evenings, and the saloons remained open all night and all day Sunday, and many of the laborers from the construction camps spent the weekends in town, drinking, gambling, carousing, and fighting.

Most people came to Bend via the Columbia Southern Railway to Shaniko, then continuing the 100 miles from Shaniko to Bend by any available means. A stagecoach could make the journey in 24 hours, providing the driver could get fresh horses every 20 miles. After 1905, there was an auto stage for adventurous travelers. Goods made the journey to Bend by freight wagon. The author of the promotional *The Bend Book* reported passing 64 freight wagons on Shaniko Road in one day, each carrying 3,000 to 4,000 pounds of freight.

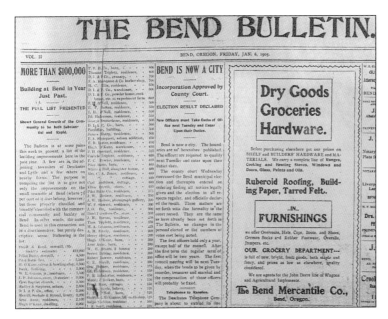

The front page of the *Bend Bulletin* on January 6, 1905, announced Bend's incorporation as a city within Crook County, Oregon. Bend remained in that jurisdiction until 1916 when Deschutes County was carved out of Crook County with Bend as its county seat. The article to the left announces "More Than $100,000" spent on completed building projects in and around Bend in 1904.

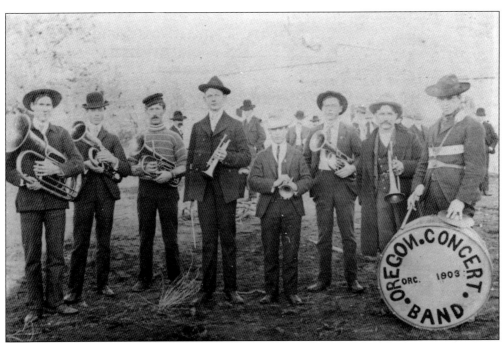

Before there was an incorporated Bend, there was a city band. This band, shown in the 1903 Fourth of July celebration on Revere Street, is one example of the civic pride that fueled incorporation.

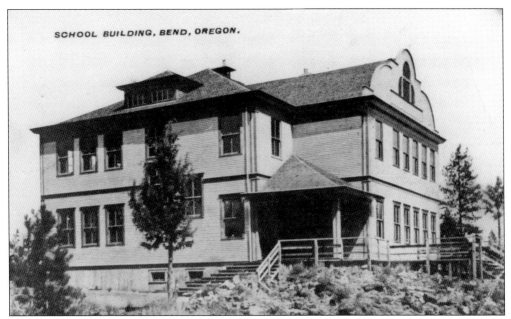

SCHOOL BUILDING, BEND, OREGON.

Shortly after incorporation, Bend voters unanimously passed a $3,500 school bond to build the new Central School to accommodate the growing school-age population. A second election authorized $5,000 more, and a third for another $6,500 passed with only two opposing votes. At first, only the first floor classrooms were used. Once the second floor was used for high school classes, students no longer had to travel to Eugene, Salem, or Corvallis, to attend high school.

Bend schoolchildren used private transportation before a public bus system was established. Central School is in the background.

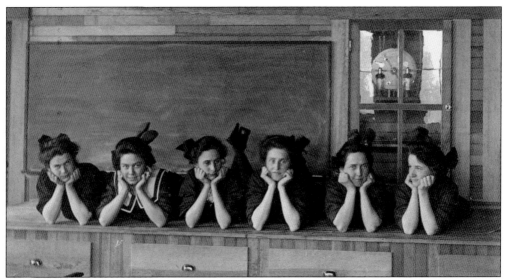

Teachers had fun at school, too. These early Bend teachers, dressed in gym clothes, mug for the camera. Maude Vandevert, second from the left, was born in Texas in 1886 and moved to Central Oregon in 1892 with her parents, who founded the Vandevert Ranch on the Deschutes River, south of Bend. She studied at home and at the Harper School south of today's Sunriver before going to high school in Salem and normal school to earn a teacher's license. She married Chester Catlow in June 1912.

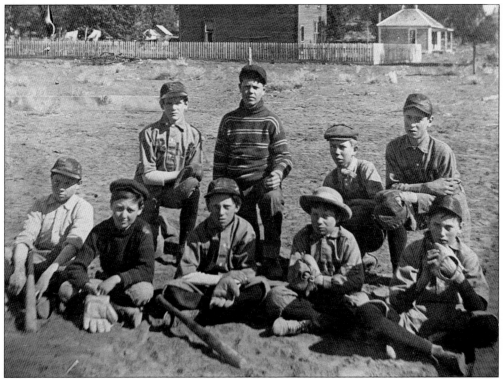

Kids also had fun outside school. Sandlot baseball was a popular pastime in 1907 for these Bend boys, all fairly well equipped with mitts, bats, and even a few baseball caps.

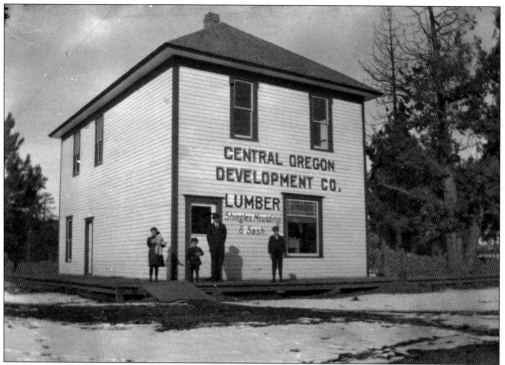

Businesses such as the Central Oregon Development Company, in this building at the corner of Wall Street and Franklin Avenue (Franklin was called Ohio at the time), promoted development by selling building materials. In addition to lumber, the company sold shingles, moldings, and sash.

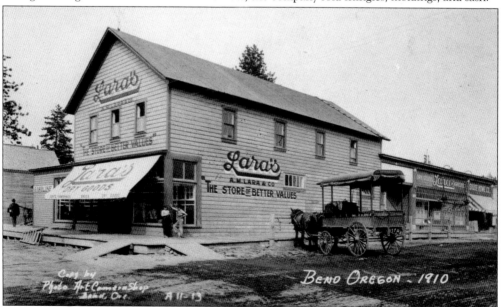

Arthur Lara came to Bend in 1907. His A. M. Lara Company purchased the Bend Mercantile Company and renamed it Lara's, "The Store of Better Values." The store was located on the northeastern corner of Wall Street and Oregon Avenue. It was torn down for construction of the J. C. Penney building, which was in business at that location from 1929 until 1988.

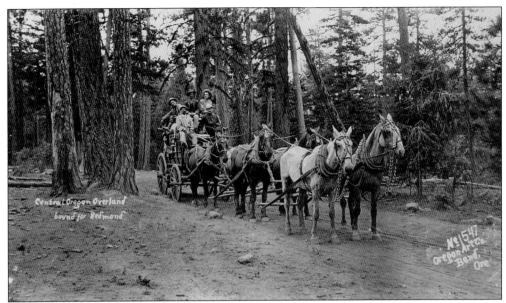

Before the railroad arrived in 1911, travelers and goods arrived in Bend via horse-and mule-drawn conveyances. The Central Oregon Overland Stage Line was one of several transportation lines that provided passenger service. This common six-horse hitch allowed the driver to negotiate Central Oregon's primitive roads.

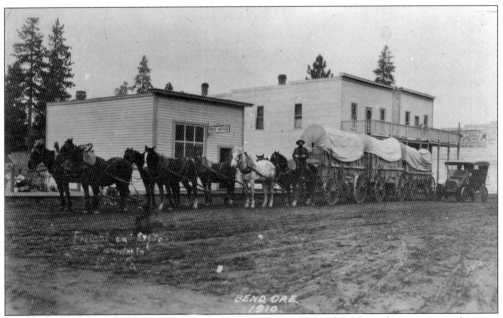

Supplies for Bend and the scattered cattle and sheep ranchers, homesteaders, trappers, loggers, cruisers, and lumbermen were freighted from Shaniko. The heavily loaded wagons, one to four to a hitch and hauled by horses, slowly made their way through axle-deep dust and mud as well as snow from one watering hole to the next. Long outfits like this one on Wall Street in 1910 were common before the railroad arrived in 1911.

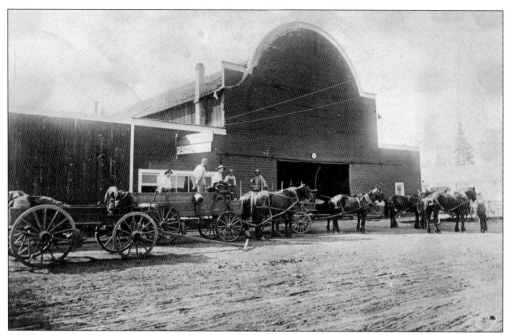

A major infrastructure supported the stage and freight lines. The Bend Livery and Transfer Company, also known as the Aune Livery Stable and Feed Store, began in 1905 and in 1908 built this livery stable that occupied half the space on the east side of Bond Street between Oregon and Minnesota Avenues. The structure stood until 1924 as a symbol of the importance of horses to Central Oregon's development.

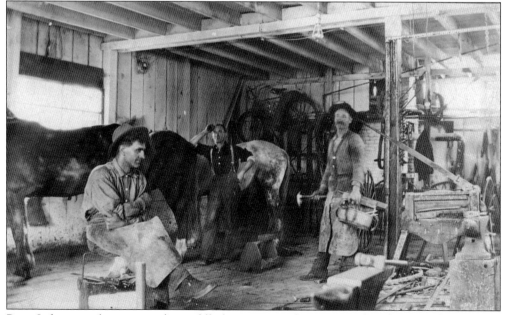

Peter Lehrman, the man in the middle leaning on a horse, owned and operated Lehrman's Blacksmith Shop on Oregon Avenue. Lehrman came to Bend in 1908 from Prineville where he had learned and followed the blacksmith trade for the previous 11 years. He had two sons and a daughter, and was a longtime member of the Knights of Pythias. He died in 1951 at age 73.

James M. Lawrence was appointed U.S. Land commissioner in Bend in 1903. He also served as city recorder from 1905 to 1906. A newspaperman, he partnered the *Bend Bulletin* and later was sole owner. Transferred to the Roseburg, Oregon, land office in 1906, he returned to Bend in 1910 and sold the newspaper to George Palmer Putnam. Lawrence then developed an insurance and loan business and served as secretary of the First National Bank.

As the U.S. Land commissioner, Lawrence worked for the General Land Office of the U.S. Department of the Interior as the local coordinator of homestead claims and other public land claims and business. He is photographed here in 1903 in front of his office in a building that also housed the office of Dr. Charles Spencer Edwards, Bend's first physician.

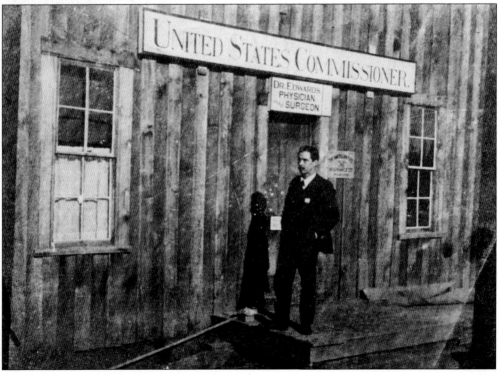

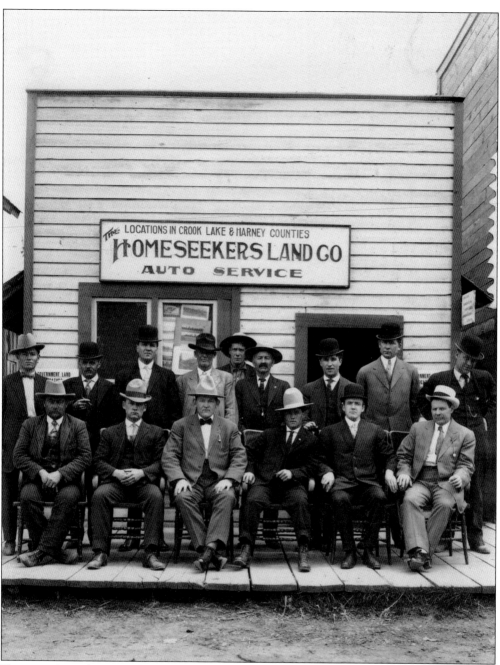

Homesteaders who arrived in Central Oregon often hired agents such as these, employed by Homeseekers Land Company in Bend, to help them locate and register homestead claims on public lands as allowed under several homestead acts. "The business requires that you follow the prospective victim from the first meeting until you land him," a U.S. Forest Service ranger of the time, John Riis, explained. "You must drive him out to the homestead and show him the lines of survey, etc." Forest Service rangers inspected claims made on national forest lands under the Forest Homestead Act of 1906. Some of these agents, Ranger Riis intimated, were more scrupulous than others.

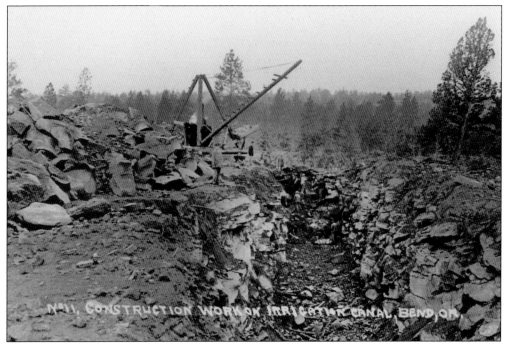

In response to the Carey Act of 1894, which promoted irrigation, reclamation, settlement, and cultivation of arid lands, construction work began on irrigation canals near Bend. Between 1904 and 1912, several irrigation companies constructed canals to irrigate thousands of acres of Central Oregon's farmland.

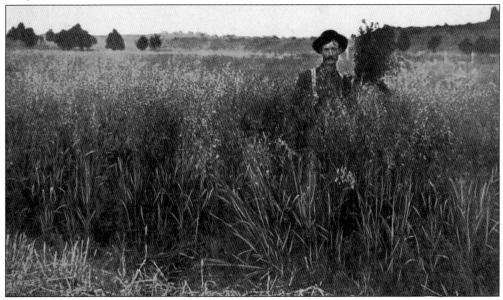

A promotion issued by the Deschutes Irrigation and Power Company included a statement by Cliff Ellis of Bend, "This is to certify that on this field I sowed one bushel of oats and sixteen pounds of alfalfa seed per acre on June 15, 1908. On September 13, 1908, I harvested three tons per acre actual measurement in stack. The land was irrigated before sowing the crop and only once after sowing."

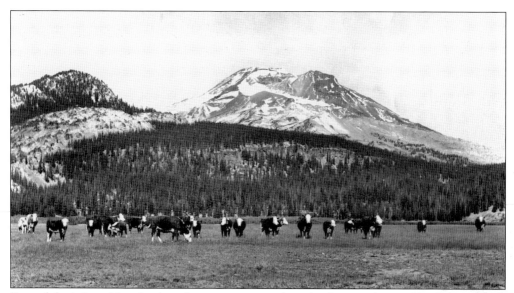

Beyond the irrigated farmlands and some non-irrigated croplands, agriculture in Bend's hinterlands was largely cattle and sheep ranching. Cattle grazed the verdant Deschutes River basin meadows and rangelands and, in the summer, the higher meadows in the forest reserves, which were renamed national forests in 1907. These cattle are grazing Sparks Lake Meadow about 25 miles west of Bend and just south of South Sister. (Courtesy of U.S. Forest Service, photograph by Leland J. Prater.)

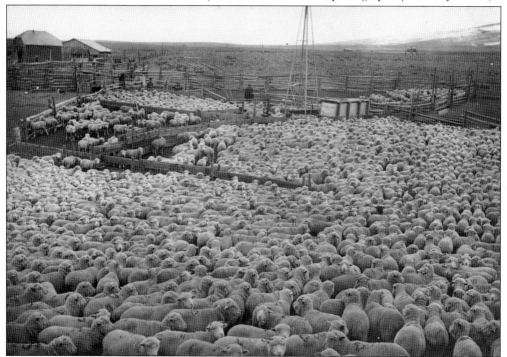

Sheep wintered on the sagebrush steppes of Central Oregon and grazed the lush high meadows of the Cascades during the summer. Herds of sheep driven through Bend to and from summer grazing often damaged residents' lawns and gardens. Here range ewes are penned at the Millican Ranch about 25 miles east of Bend.

From 1909 to 1914, Dr. Urling Coe saw Bend and Central Oregon patients at Mrs. Hall's Hospital on Oregon Avenue and throughout the region, which he traveled by horse and buggy. Dr. Coe arrived in Bend in 1905 after attending the University of Missouri and the Eclectic Medical College in Cincinnati, Ohio. He was active in the early development of Bend, a leader in establishing Bend's first hospital, and also a banker, a real estate dealer, and mayor.

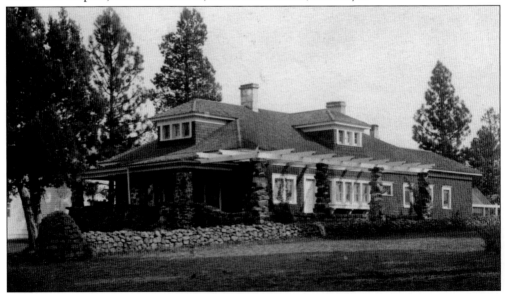

Arthur Goodwillie, Bend's first mayor, and his wife, Grace, built this house near the Drake house in 1908. It later became the home of Herbert Allen, a Brooks-Scanlon Company executive, and his wife, Alice. Dr. Clyde and Marjorie Rademacher then owned the house. Later moved to 875 NW Brooks Street, the Goodwillie-Allen-Rademacher House now hosts a nonprofit arts organization.

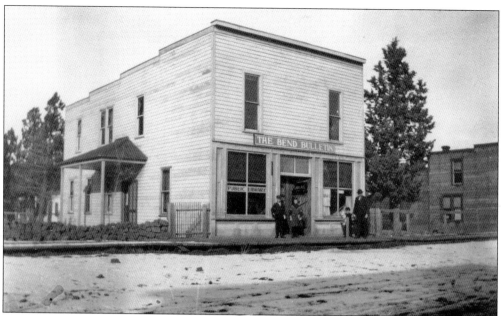

The *Bend Bulletin*, now called the *Bulletin*, has been Bend's newspaper since 1903. Its second home was in the first J. M. Lawrence building on the west side of Wall Street at the north end of Drake's rock wall. Lawrence donated space for Bend's first library, which he and his wife founded.

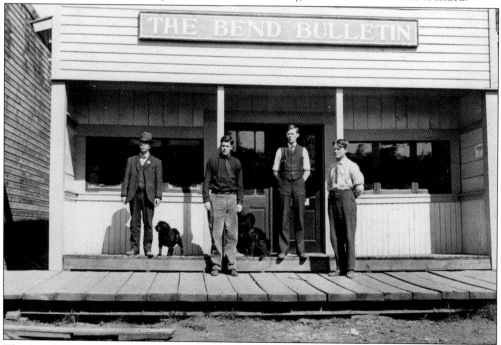

The fourth *Bend Bulletin* office was in the Seller building on Bond Street. Shown from left to right are J. M. Lawrence; George Palmer Putnam, publisher; C. D. Rowe, editor; and Ralph Spencer, reporter. Putnam, who arrived in Bend from New York in 1909, was a Bend booster who went on to serve as Gov. James Withycombe's private secretary in Salem before returning to the family publishing business in New York.

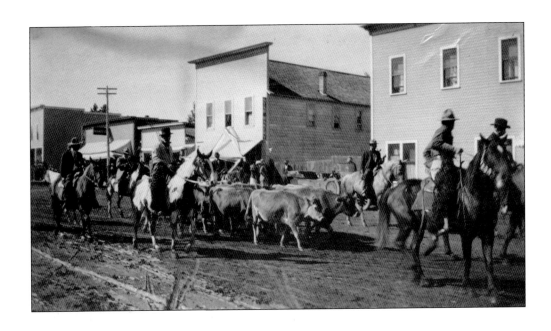

Bend remained a cow town during its early years as an incorporated city. Buckaroos routinely drove cattle and raced horses through town to celebrate the Fourth of July. This race, in 1909, occurred two months after Putnam arrived.

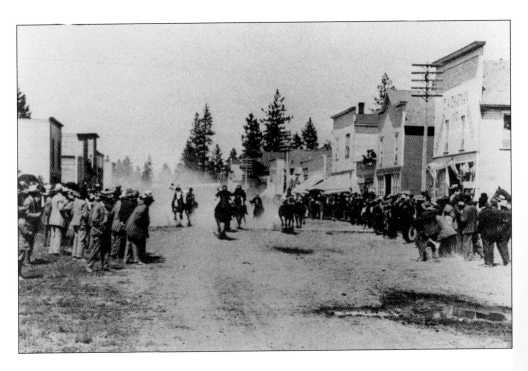

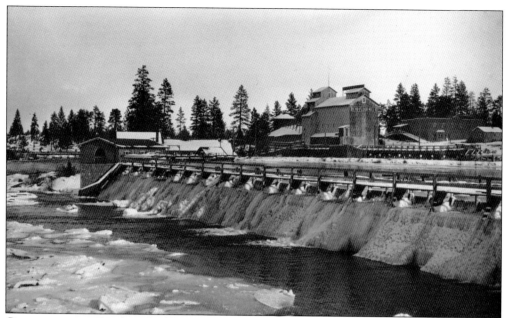

Cow town or not, Bend was building for the future. The Bend Water, Light, and Power Company's dam on the Deschutes River brought electricity to downtown Bend in 1910. Operation of the Bend Flour Mill, the tall building in the background, was made possible by the dam and the electricity it generated. The dam and powerhouse near the Newport Avenue Bridge are still used by Pacific Power and Light.

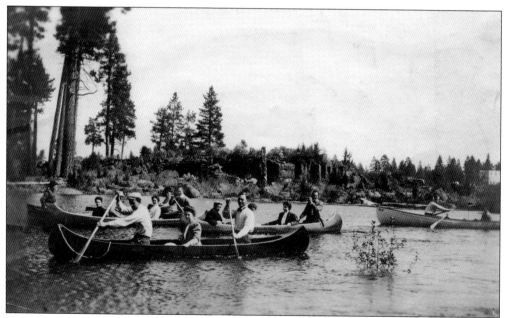

Canoeists enjoy Bend's new Mirror Pond, which was created when the Bend Water, Light and Power Company dam was completed. The new Linster Opera House on the hill at the intersection of Wall Street and Vermont Avenue is visible on the right. The hall burned in October 1912 and was not rebuilt.

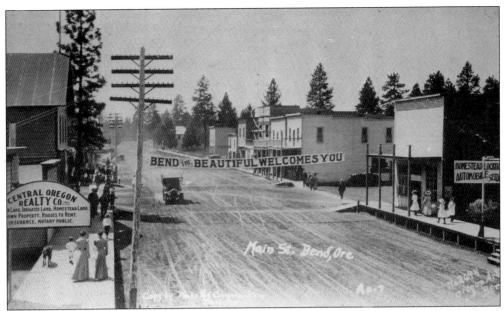

"Bend the Beautiful" was on the cusp of change in 1910. This change, wrought by a railroad's arrival, transformed the five-year-old city of about 535 souls into a small but thriving industrial city of 10 times that number within as many years. "Main St. Bend, Ore" in this photograph taken in 1910 from mid-block between Oregon and Greenwood Avenues is today's Wall Street, looking south.

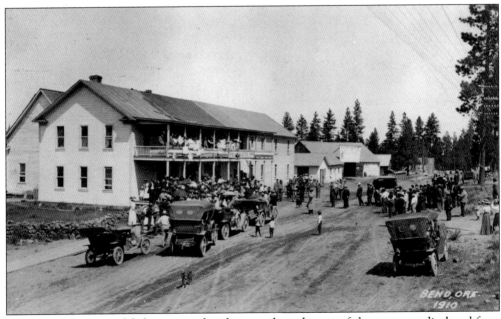

The "Bend the Beautiful" banner in the photograph at the top of the page was displayed for a celebration that gathered many at the old Pilot Butte Inn, shown in this photograph taken looking north on Wall Street on the same day in 1910. This celebration was small compared with the one that marked arrival of the railroad in Bend a year later.

Three

A CITY TRANSFORMED
1911–1918

These years saw Bend grow from a village into a prosperous and well-established mill town. The first ingredient in this transformation was the railroad. Prior to 1911, Bend was isolated from the rest of the world because it had no connection to the interstate rail network.

Railroad tycoons James J. Hill and Edward Harriman began building rival railroads toward Bend in 1909. Hill's Oregon Trunk Railroad was successful in reaching Bend in 1911.

With a railroad in place, two lumber companies from the Great Lakes region began building mills. The Brooks-Scanlon and Shevlin-Hixon Companies had acquired extensive timberlands near Bend early in the century. Their new mills were designed to cut 400,000 to 600,000 board feet of lumber per day. To sell that much lumber, they had to reach customers throughout the United States and Europe. World War I made for a brisk international lumber market from 1914 until 1918.

Newcomers flocked to Bend to work in logging and lumber manufacturing. The population grew to 5,000 by 1918. Many were from the Great Lakes region, and many of those were of Scandinavian descent. Mill workers lived with their families in bungalows in residential neighborhoods near the mills. Loggers lived in camps operated by the companies. After the first few years, many of the loggers brought their families to the camps of portable cabins and schools, company stores, and other comforts of home.

When loggers and stockmen came to Bend on Saturday nights, they found a town bursting at its seams. New businesses on Wall Street and Bond Street offered all sorts of merchandise and services. Retailers on Wall Street sold goods previously available only in Portland or other cities. Bond Street had the reputation of being a little rowdy, with restaurants, saloons, and some shady hotels.

Oregon novelist H. L. Davis commented that on any street corner in Bend a person could hear loggers speaking Norwegian, buckaroos speaking Spanish, and sheepherders speaking Gaelic. Bend was becoming quite a cosmopolitan place.

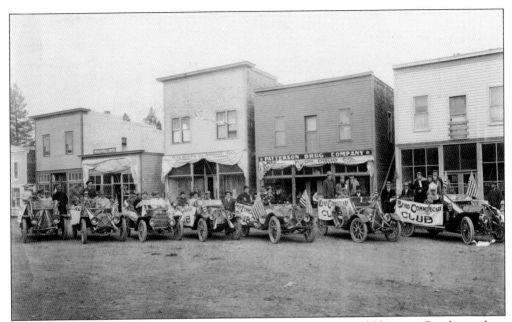

Knowing the growth that Oregon Trunk Railroad's completion would bring to Bend, members of the Bend Commercial Club drove 130 miles east to Burns, Oregon, in an effort to promote development of the road between the two towns and to call attention to the rail facilities that would benefit Harney County, too.

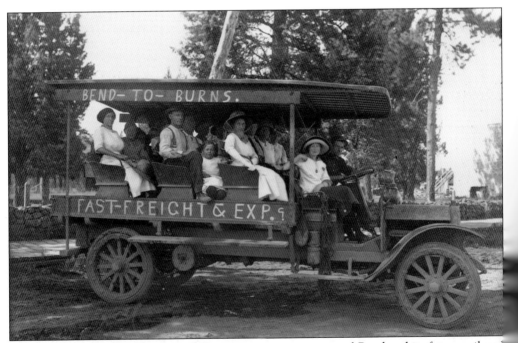

The Bend-to-Burns Fast-Freight and Express auto stage connected Bend and its future railroad to Burns. "The best bucker at the Pendleton Round-up is but a rocking-horse in comparison," a passenger from the East wrote. "I doubt you could experience death in any part of the world more times for twenty dollars than by auto-stage from Bend to Burns."

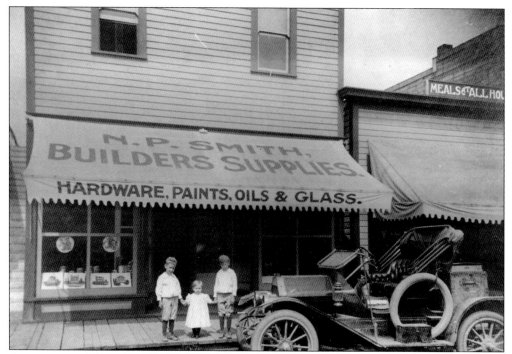

Anticipation of the railroad helped Bend grow. N. P. "Nick" Smith moved his hardware store into this building he constructed on Wall Street in 1910. The building survived the fires that destroyed many downtown wooden structures. From left to right, Smith's children, Elmer, Marjorie, and Lester, stand on the wooden sidewalk. Marjorie lived upstairs in the building into the 21st century. The building remains as the last of Wall Street's early wooden structures.

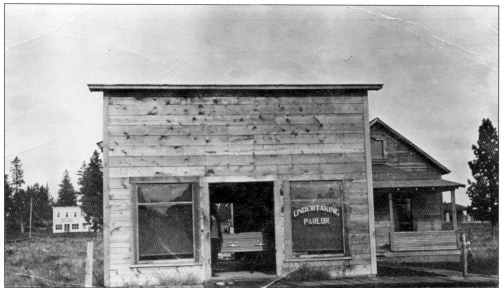

C. P. Niswonger, a brick mason, earned a mortician's license through a correspondence school, became Bend's first undertaker, and built the city's first undertaker's parlor in 1912. His personal home was to the right of the parlor. "Neither building is finished," he commented on this photograph. "We are going to finish both in the spring if God lets us."

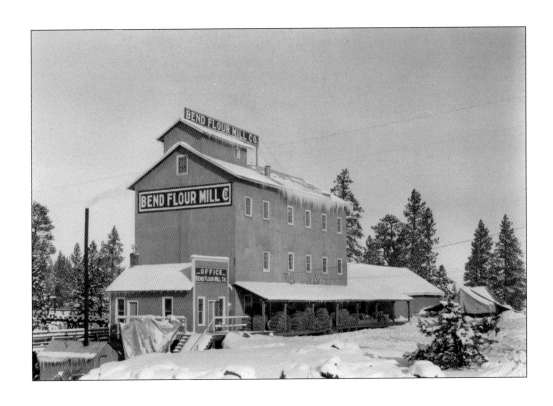

Built to mill wheat from Bend's surrounding wheat lands, the Bend Flour Mill Company began operations in 1911 with good prospects of success as a major employer. The mill advertised high patent, straight-grade whole wheat, graham, or rye flour, along with grits, breakfast food, bran, shorts, and all kinds of feed. The flour mill company also sold agricultural implements such as wagons and farm machinery. Financial troubles caused the mill to close in 1920. The Deschutes Farmers Association then used the structure as a warehouse until it burned in 1940.

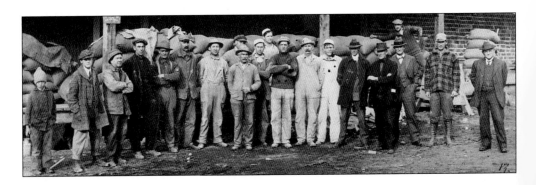

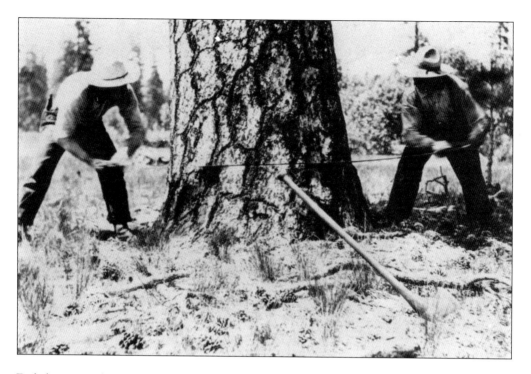

Early loggers with two-man crosscut saws called "misery whips" felled large western yellow pines (called ponderosa pine since the 1930s) in the forests that surrounded Bend. The logs they cut supplied several small mills that provided lumber for local and, beginning in 1911, regional markets to which they could ship by rail. One of these, the Bend Company sawmill, prospered until it burned in 1915. Within five years of the railroad's arrival in 1911, a great increase in logging was necessary to supply logs to two giant pine mills on the Deschutes River that began production in 1916.

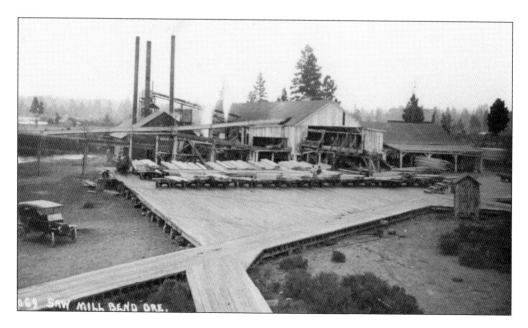

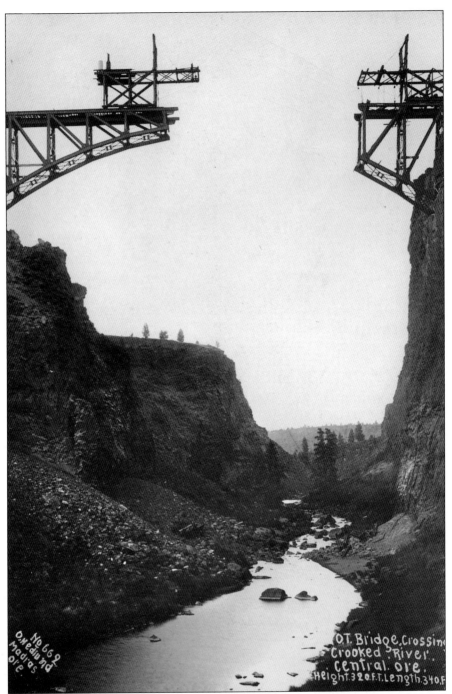

Completion of a railroad bridge over the Crooked River Gorge in 1911 permitted completion of the Oregon Trunk Railroad to Bend that year. "And what a bridge it was," Warren Carlson wrote in *Cascades East Magazine*. "The graceful, 340-foot steel arch spanned the canyon over 300 feet below. To build it, workers anchored frames to the cliff on both sides, then lifted and fitted sections until the pieces could be fastened together at the middle. It was considered one of the engineering marvels of the world at the time."

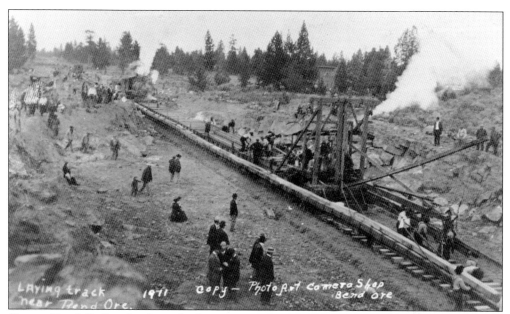

Laying track 1911 Copy — Photo Art Camera Shop Bend Ore
near Bend Ore.

Oregon Trunk Railroad rails reached the outskirts of Bend in September 1911. Townspeople turned out to see the track-laying machine in operation as the railroad neared the city limits. The excited onlookers knew the railroad would bring big changes to their city and their lives.

James J. Hill, "The Empire Builder" of the Great Northern Railroad, spoke and drove the golden spike on Railroad Day when his Oregon Trunk Railroad reached Bend on October 5, 1911. He and rival Edward H. Harriman of the Union Pacific Railroad had fought a bitter contest to build the railroad to Bend. Their legendary race ended in agreement for the two railroads to share tracks and terminal facilities in Bend.

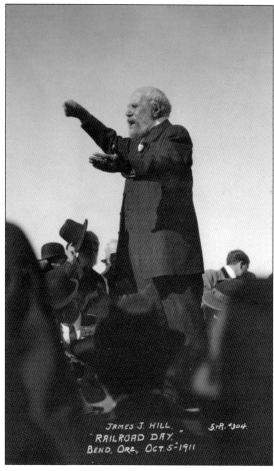

JAMES J. HILL, SnP. 1904
RAILROAD DAY,
BEND, ORE, OCT. 5-1911

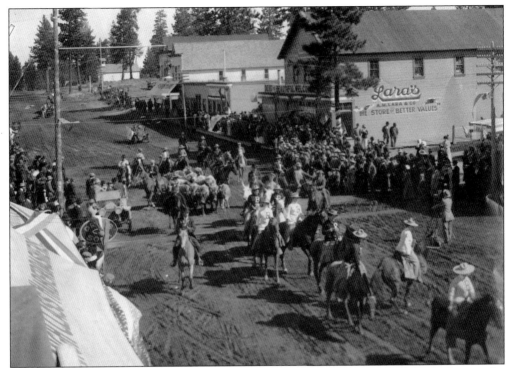

Railroad Day was enthusiastically celebrated. "The main street was roped off for the big parade; canoe races and logrolling on the river, speech-making and a rodeo . . . were on the program. The town was awhirl with excitement, surging back and forth from the main street down to the tracks where the last few rods of rail were being spiked down," wrote Ranger John Riis of the U.S. Forest Service in his 1937 book, *Ranger Trails*.

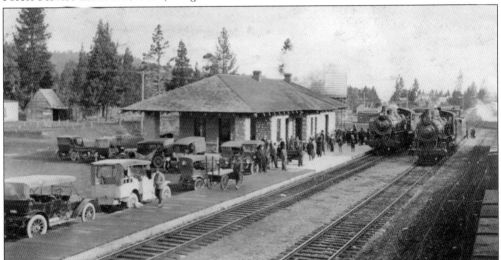

The cornerstone for Bend's railroad depot was laid on Railroad Day. The depot was built of volcanic tuff quarried on Bend Company property. The railroad connected Bend with the outside world and brought economic growth. Passengers and freight arrived and departed daily, and the railroad transported Bend-area livestock and timber to markets. The depot was moved to the west side of the Deschutes River in 1999 to make way for Bend Parkway construction.

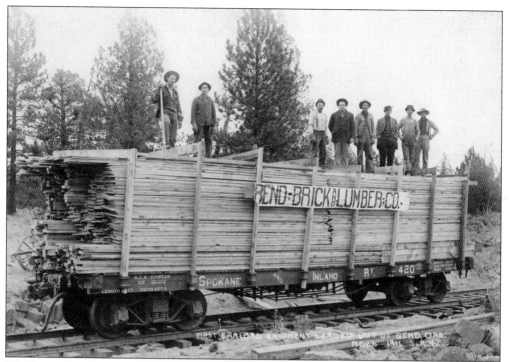

The first railcar shipment of lumber from Bend left the Bend Brick and Lumber Company west of Bend on November 6, 1911. The same railcar had arrived loaded with brick-making equipment. The new equipment increased the quality and quantity of bricks manufactured, reflected in the increased number of brick structures built in the area.

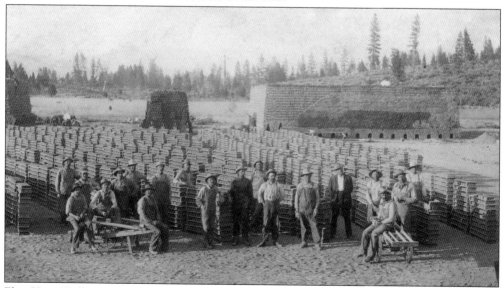

Elsie Horn Williams penned a note that read, "Remember when every youngster in Bend earned his spending money out at the brickyard? Turning bricks, covering them with pallets, turning the pallet wheel, re-pressing the bricks." Williams's family owned the brickyard between the west side of Bend and Shevlin Park from 1912 to the late 1920s. The site became racetrack and rodeo grounds in 1932.

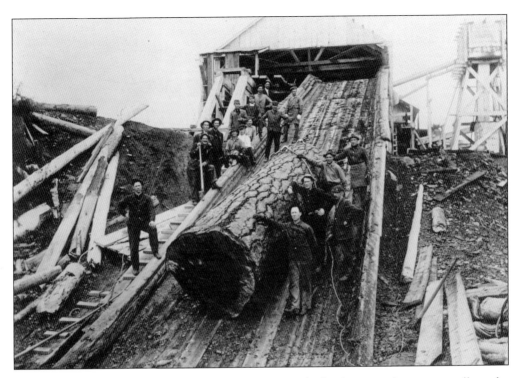

Louis Gless, Bill Bevans, and George Grove are among the lumbermen who pose proudly at the Bend Company sawmill in 1913 with one of the largest western yellow pine logs put through the mill on its way up the slip to the saw. The log scaled at 2,500 board feet. The Bend Company mill was on the Deschutes River just north of what is now Columbia Park. It was destroyed by fire in 1915, shortly before the giant Shevlin-Hixon Company and Brooks-Scanlon Company mills began operations in 1916.

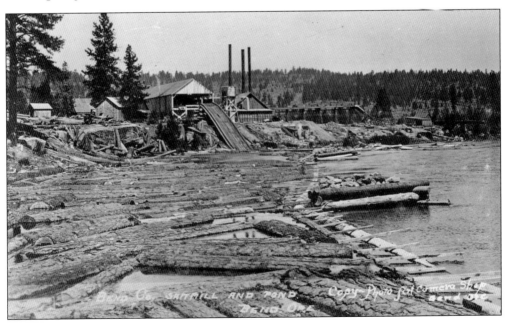

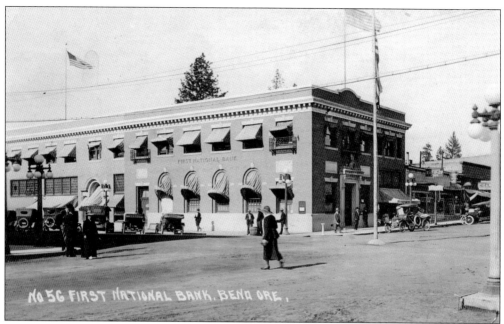

No 56 FIRST NATIONAL BANK. BEND ORE,

Bend's financial institutions grew with the city. The First National Bank opened for business in March 1909, at the corner of Wall Street and Franklin Avenue, and later moved to this imposing structure built in 1912 on the northwest corner of Bond Street and Oregon Avenue. Offices on the second floor included those of the Bend Park Company and Dr. Urling C. Coe. One of two metal signs found under the Reid School (now the Des Chutes Historical Museum) during its 2000 renovation and reconstruction shows that Dr. Coe was also vice president of the bank.

47

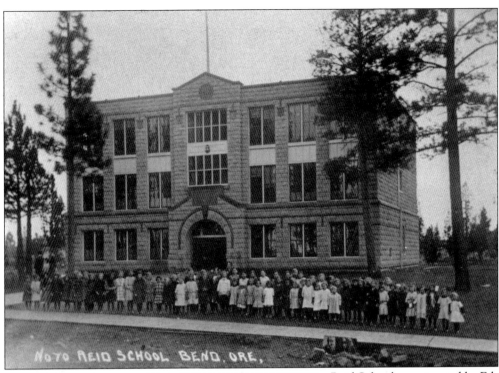

No. 70 REID SCHOOL BEND, ORE.

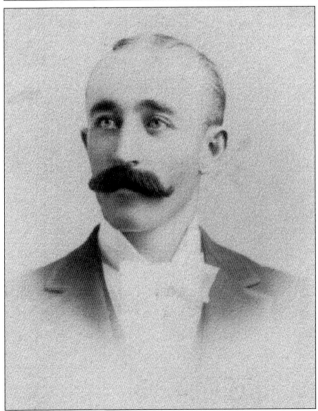

Reid School, constructed by Ed and George Brosterhaus and completed in 1914, was named in honor of Ruth Reid Overturf, the first Bend School District principal and an exceptional leader in education. Brosterhaus Road in Bend is named for these early contractors. George (left) was killed in a construction accident on the school project. Reid School was touted as "the first modern day school" in Bend. It was built of native stone and had indoor lavatories and a central heating system. The building is now home of the Deschutes County Historical Society and houses the Des Chutes Historical Museum.

Kathleen Eloisa Rockwell loved the stage life. She performed in New York and Seattle, and in 1898 she was drawn to the Yukon gold rush. There the young entertainer was nicknamed "Klondike Kate." Kate arrived in Bend in 1914, homesteaded 3 miles northeast of Brothers in 1917, and later returned to Bend and built a house on Franklin Avenue. "Aunt Kate" was known as a true humanitarian, whether providing a pot of stew or coffee to "gentlemen of the road," bringing coffee and doughnuts to Bend's firefighters, or caring for the sick during the 1918 flu pandemic. She was philosophical about her life of success and failure, "When you think your heart is breaking, mush on and smile. When you feel you've been forsaken, mush on and smile." Kate lived in Bend until 1948, then married and moved to Sweet Home. She died in 1957. Her house at 231 Franklin Avenue was razed in 1979.

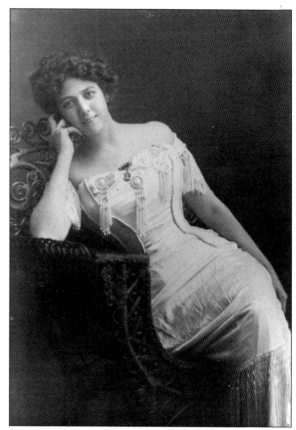

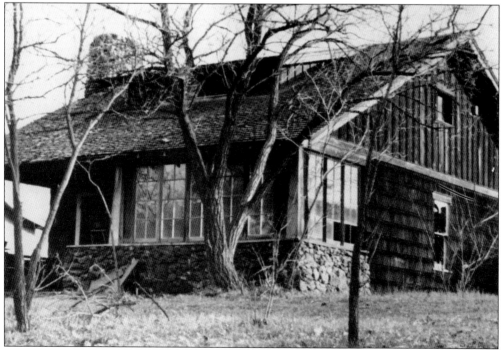

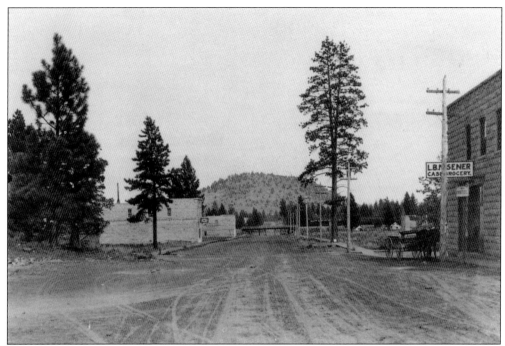

Greenwood Avenue, shown here, looking east toward Pilot Butte from Bond Street in 1915, was the route of Oregon State Highway 54, which passed under the railroad trestle. The stone building on the right, constructed in 1912, housed the Wright Hotel and a grocery store. The stone J. I. West building on the left, built in 1911 at 130 NW Greenwood, was reputedly the first stone building in Bend and originally housed the Hotel Oregon. It remains in use today.

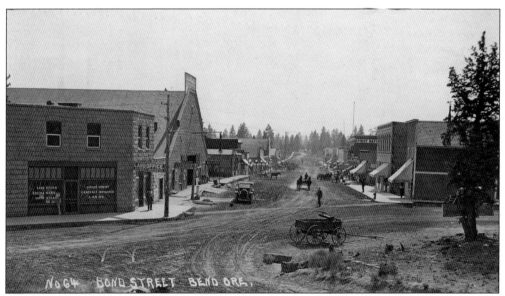

Bond Street, shown looking south from Greenwood Avenue in 1915, was a main thoroughfare in Bend's central business district. On the corner on the left is the Wright Hotel. The tall building next door is the Wenandy Livery Stable. The modern Boyd Building now occupies this corner.

In 1915, with the Oregon Trunk Railroad in place and World War I in Europe creating a strong market for lumber, the Shevlin-Hixon and Brooks-Scanlon lumber companies began construction of two large mills in Bend. Both companies were well established with mills in the United States and Canada. This is a view of the Shevlin-Hixon mill from the east side of the Deschutes River.

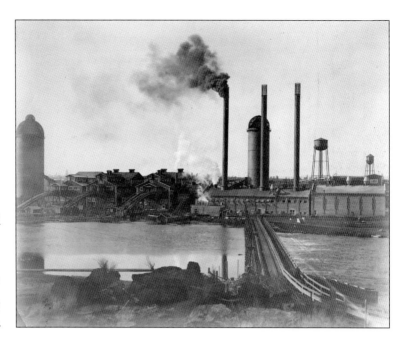

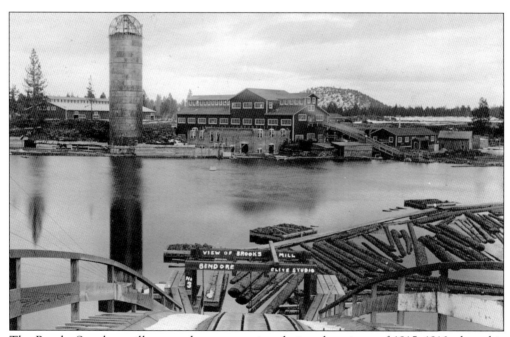

The Brooks-Scanlon mill was under construction during the winter of 1915–1916 when this photograph was taken from the top of the Shevlin-Hixon mill log slip. The two new mills were designed to cut a million board feet of lumber each day between them. In addition to producing lumber, the new mills processed lumber into products ranging from building materials to boxes to ironing boards. The two mills shared a millpond.

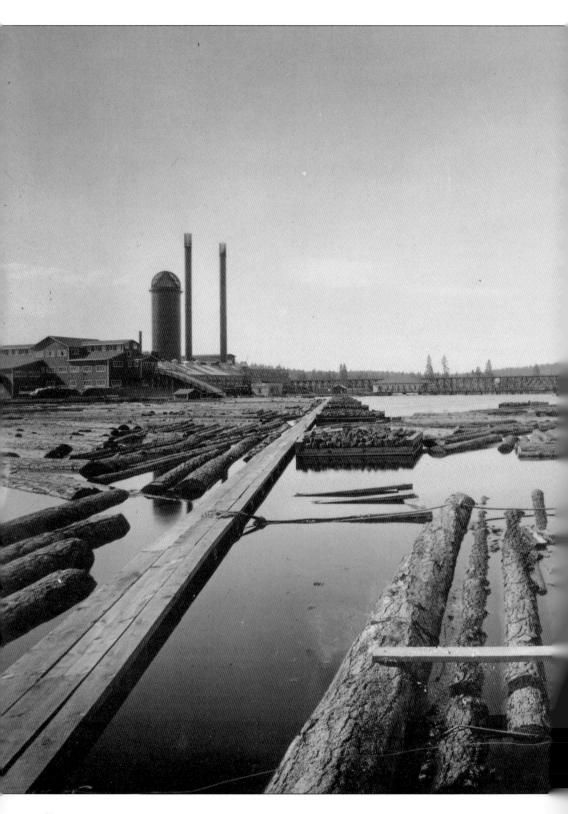

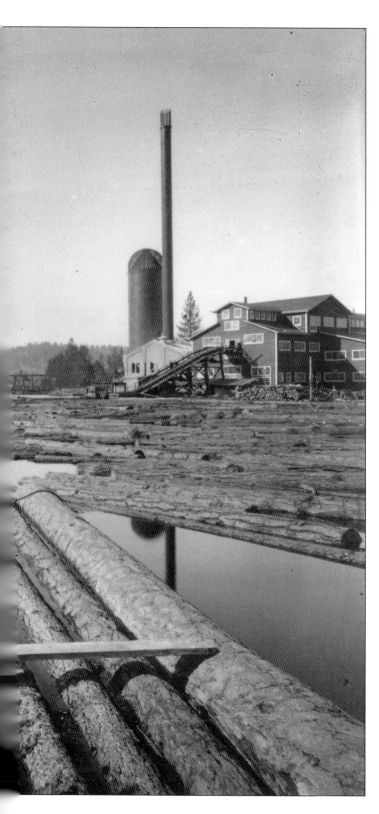

The Shevlin-Hixon mill on the western bank (left) and the Brooks-Scanlon mill on the eastern bank (right) faced each other across the Deschutes River and their shared log pond from construction in 1915 until the Shevlin-Hixon mill was closed in 1950. They were the economic mainstays of Bend for several decades.

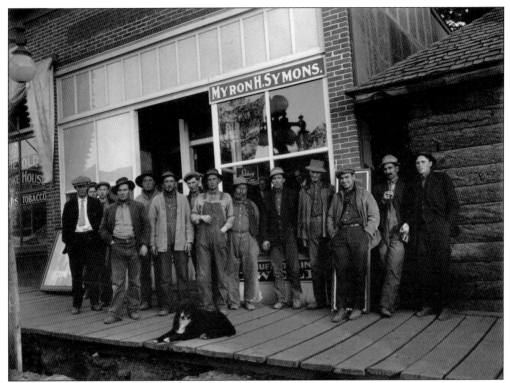

The mills brought work for many and wealth for some. Mill workers and others who worked at jobs generated by the lumber industry—such as these on the board sidewalk in front of Myron H. Symons' jewelry store on Bond Street—earned good wages and patronized such businesses as The Old Smoke House tobacco shop on the left and Mike McGrath's Log Cabin Saloon on the right.

In 1916, Tom McCann assumed the position of vice president and general manager of the Shevlin-Hixon Company mill in Bend. His imposing residence, built at 440 NW Congress Street, that same year, still stands.

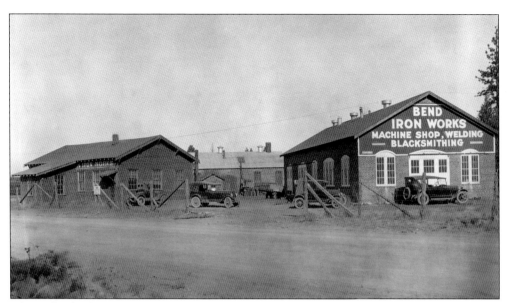

The mills also brought supporting industries, businesses, and professions. Charles Dugan and R. E. Huffschmidt from Portland started the Bend Iron Works in 1916. Its foundry produced castings for logging and milling as well as mining and construction. A machine shop added in 1919 expanded its product line, which focused on sophisticated mill machinery sold throughout the United States and Canada after World War II.

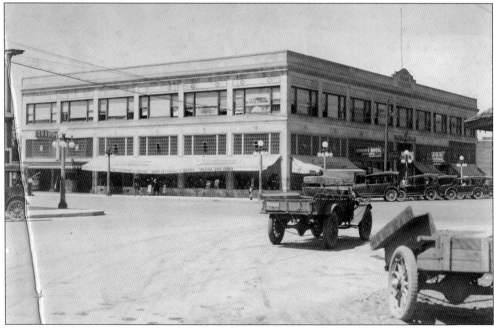

Constructed by Hugh O'Kane in 1916, the O'Kane building on the southwest corner of Bond Street and Oregon Avenue has been in continuous use as a retail and office building since its construction. Early occupants of the concrete structure were doctors Vandevert, Edwards, Manning, and Ferrell. O'Kane, an Irish immigrant who settled in Bend in 1904, first built the Hotel Bend on this site. It was destroyed by fire in 1915.

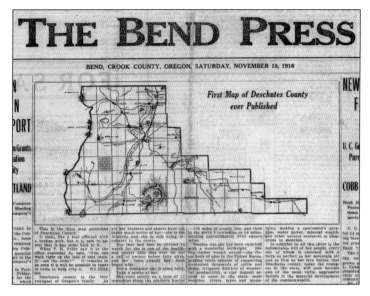

First Map of Deschutes County
ever Published

Bend rapidly grew larger than Prineville, county seat of Crook County, by which Bend felt neglected. On December 13, 1916, Bend became county seat of Deschutes County, the 36th and last county created in Oregon. The November 18, 1916, issue of the *Bend Press* shows the first map of the county proposed to be carved out of Crook County.

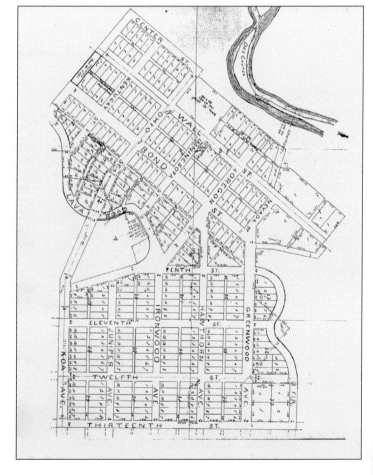

As the city grew, Bend's street names evolved. Many core area street names date from 1904. A significant number of changes were made in 1912, 1913, and 1916. City Ordinances 87 and 20 set forth an odd-even numbering system and the use of terms such as street, avenue, and road. Later Ordinances 47 and 60, both adopted in 1910, vacated some streets, including First Street, for the Oregon Trunk Railroad.

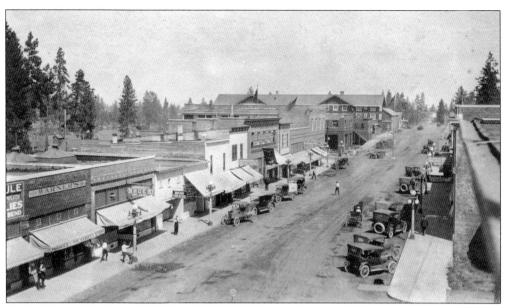

In this view looking north along Wall Street in 1917, Deschutes County's soon-to-be county seat looks ready for the honor. A lone horse-pulled conveyance passes "modern" automobiles parked outside many buildings that still stand in Bend as it makes its way toward Wall Street's intersection with Oregon Avenue.

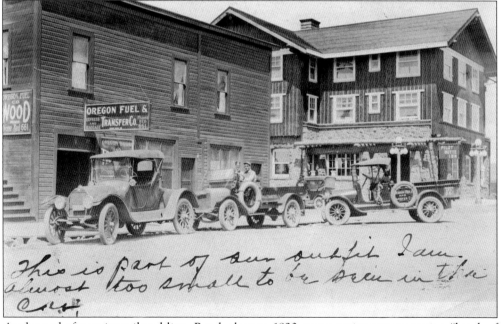

At the end of a major railroad line, Bend, close to 1920, was a major transportation "break of bulk" point at which businesses such as the Oregon Fuel and Transfer Company provided vital services. Its garage, at the southwest corner of Wall Street and Newport Avenue, was just across from the Pilot Butte Inn that was constructed in 1917.

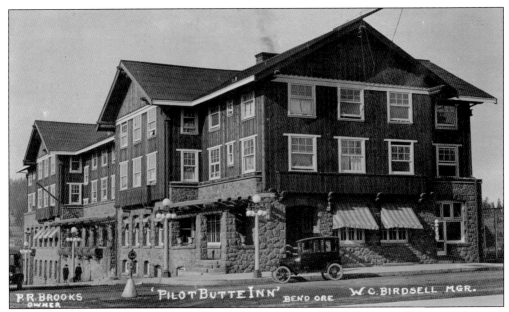

Bend's luxurious Pilot Butte Inn, on the northwest corner of Wall Street and Newport Avenue, opened on St. Patrick's Day in 1917 as the third building to bear the name. Built by Phillip Brooks of British Columbia, a distant relative of the Brooks timber family, it quickly became a Central Oregon landmark. When it was razed in 1973, its stone fireplace was carefully dismantled and reassembled at the Athletic Club of Bend on Century Drive.

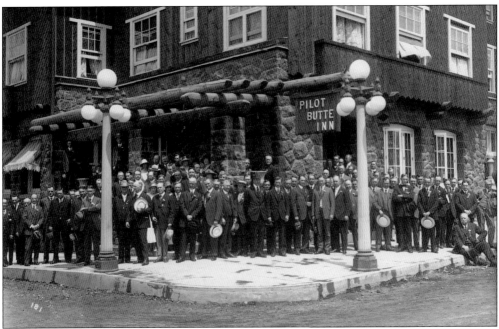

During its almost half century, the Pilot Butte Inn played host to the rich and famous as well as thousands of other visitors to Central Oregon and served for many as the center of community life. This group, mostly men sporting name tags or ribbons on their lapels, appears to be attending a convention. The hotel initially had 60 guest rooms and expanded to 150 rooms in the 1930s.

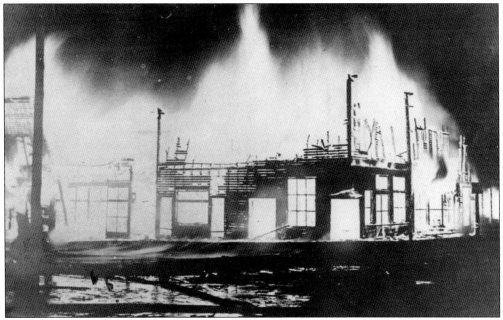

Fire menaced early Bend's wooden downtown. The city's earliest recorded fire occurred on April 27, 1905, at the corner of Bond Street and Oregon Avenue. It destroyed O'Kane's saloon and bowling alley, Estebennet's saloon, and Erickson's lodging house. This fire at the northwest corner of Wall Street and Oregon Avenue on July 3, 1912, destroyed several businesses and the post office. Only heroic efforts of the firefighters saved the stores across Wall Street.

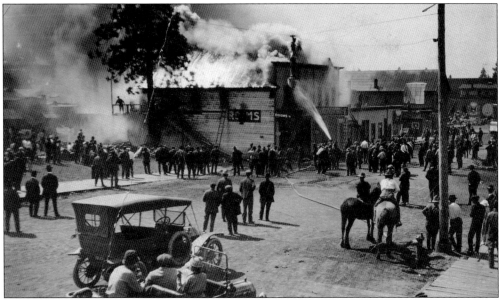

A large crowd gathers here on April 23, 1916, to watch as the roof burns on "Dad" West's building on Wall Street as firemen turn water hoses on the windows. Eleven years earlier, in 1905, the newly incorporated city installed its first fire protection system. Costing $1,395.50, this consisted of street hydrants, fire hoses and carts, ladders, and nozzles. Volunteers fought all fires. City ordinances eventually required construction of less flammable structures.

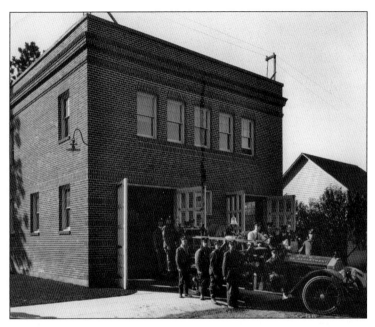

When the Bend Fire Department was formed in 1919, it still relied on volunteers. These proud firemen stand with their fire apparatus in front of the Bend Fire Department fire hall on Minnesota Avenue. Expanded, it housed the department's downtown station into the 21st century.

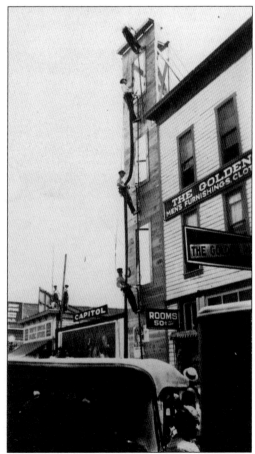

Bend Fire Department firefighters practiced their firefighting skills often. Here, on the Golden Rule men's furnishings shop at 865 Wall Street, they advance a hose line to the height of a four-story building.

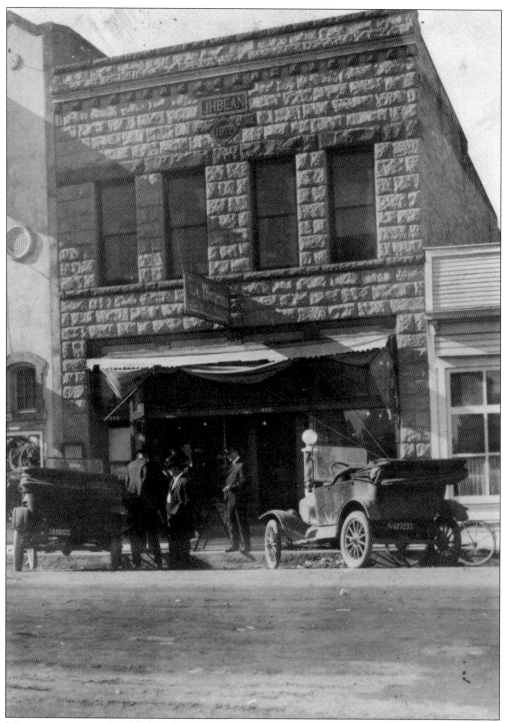

Masonry structures, less likely to burn, eventually replaced wooden structures in downtown Bend. This building of pink volcanic tuff, constructed in 1912 at 855 Wall Street for J. H. Bean, housed the E. M. Thompson Furniture Company beginning in 1913. Later Bend residents knew it as the Skyline Steakhouse. The building to the left is the Liberty Theater, which opened in 1917.

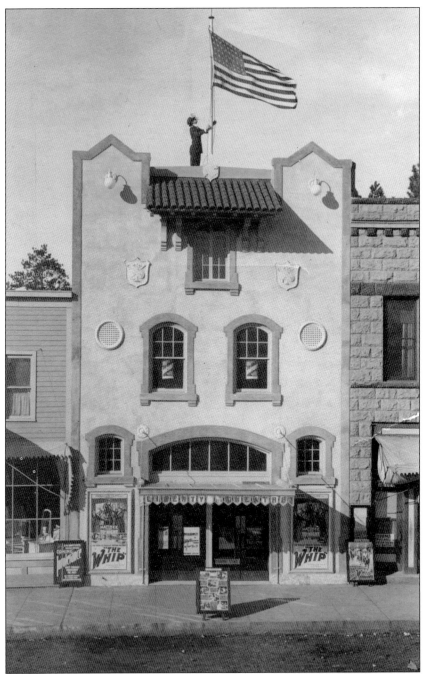

This photograph was made soon after the Liberty Theater opened on Wall Street. The movies showing that week in 1917 were *The Whip* and *Polly of the Circus*. This theater operated through 1945 and was very popular with soldiers training at Camp Abbot during World War II. Saturday was "Pal Day" with two admissions for a nickel. The modern Tower Theater that opened on the same block in 1943 to serve the wartime influx of moviegoers eventually put the older Liberty Theater out of business. By 1954, the building had been renovated for use by Sears, Roebuck and Co. It served as a real estate office in the 1970s.

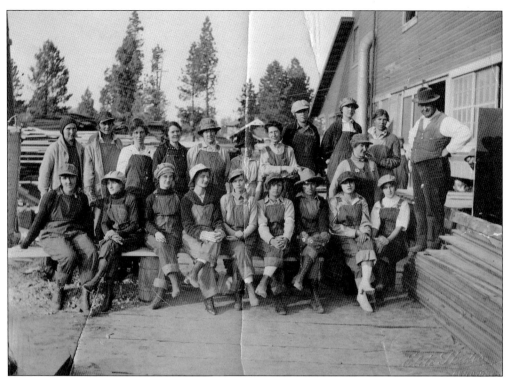

Bend and the rest of the nation suffered severe shortages of workers when the United States entered World War I in 1917. Young men were called into the armed forces in great numbers, and other workers were required by defense industries. As a result, just as their daughters characterized as "Rosie the Riveter" would in World War II, crews of women such as these photographed at the Brooks-Scanlon Company box factory helped carry on the work in Bend's mills. Others replaced men in other occupations.

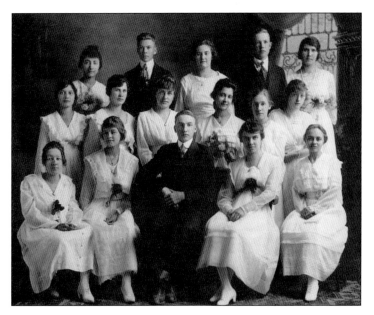

Bend High School graduated 15—three men and 12 women—in 1918. Pictured here from left to right, they are (first row) Rae Knickerbocker, Evelyn Ragsdale, Eugene Fulton, Ida Niswonger, and Nellie Snider; (second row) Minnie Dorsett, Jennie Creighton, Mabel Lorence (class advisor), Mable Sphier, Mary Sherrer, and Gail Forbes; (third row) Rose Sphier, Art Norcott, Carol Boyd, Calvin Smith, and Mary Stauffer.

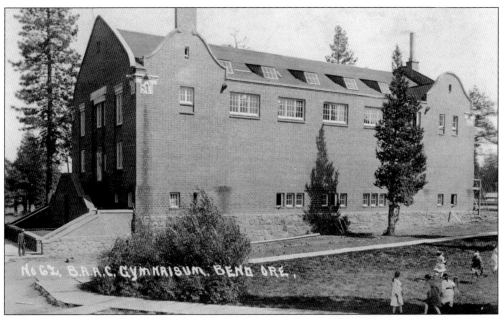

Built in 1918 at 520 Wall Street, the Bend Amateur Athletic Club served as a hospital during that year's flu pandemic. In 1919, fifteen hundred people gathered there for a revival featuring famous evangelist Billy Sunday. In 1923, the building was purchased by the Bend School District and was the city's only large auditorium for school and community events. It was the high school gymnasium until Bend High School moved to its Sixth Street campus in 1956. It became the Bend Boys and Girls Club in 1996.

Four

AN ERA OF GROWTH
1919–1927

Bend developed distinct neighborhoods. Mill workers tended to live in bungalows north of the Brooks-Scanlon mill on the east side of the Deschutes River and north of the Shevlin-Hixon mill on the west side of the river. Business and professional families chose neighborhoods on either side of Drake Park. The Kenwood neighborhood on the west side and the Allen School neighborhood on the east side appealed to small business owners and tradesmen.

Each neighborhood had a store, a school, and other basic services. In an era when people walked to work and the store, proximity was important. Many families preferred bungalow-style houses.

Downtown commercial buildings also changed. The first were wooden-framed storefronts. After major fires, these were replaced with brick and stone structures. Only one downtown wooden building, the N. P. Smith Hardware Store, survived the change to masonry. It still stands at 935 NW Wall Street.

Some businesses begun in the late 1910s and 1920s remained for many years. The Symon Brothers' jewelry store, Cashman's men's store, Joe Egg's blacksmith shop, Aune's feed store, the Bend Hardward Company store, and others were downtown fixtures. Most famous was the Pilot Butte Inn, built in 1917. This elaborate, rustic-style hotel reigned on the corner of Newport Avenue and Wall Street until 1973.

As the town grew, the infrastructure grew. Streets were paved and maintained. Schools like Kenwood and Reid and the old Bend High School reflected civic pride. The old Amateur Athletic Club and many central churches date to this period.

The 1920s was a decade of music and dancing and sports. Paul Hosmer, writer and Brooks-Scanlon press agent, often played banjo and led his dance band at the Hippodrome, a popular dance hall at the corner of Wall Street and Louisiana Avenue. Skiing arrived with Norwegian mill workers, and the Bend Skyliners became one of the largest mountaineering clubs in the Northwest. Bend fielded the Bend Elks baseball team.

The timber industry that sustained Bend's growth was itself sustained for decades by Deschutes National Forest timber, once most private timberlands had been cut over by the mid-1920s.

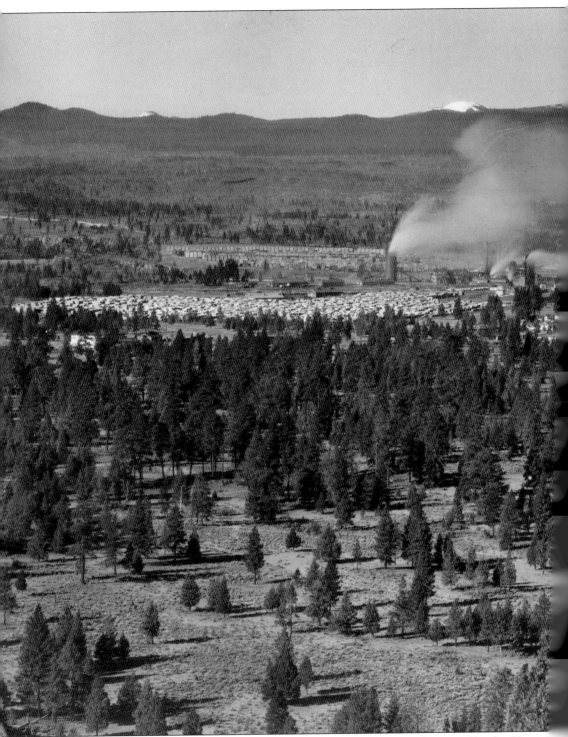

As the second decade of the 20th century closed and the third began, the giant Shevlin-Hixon Company and Brooks-Scanlan Company mills dominated Bend's townscape—as seen from Pilot Butte in this 1920 photograph—even as they supported the young city's growth. The lumber

drying yards of each appear in the right middle ground of this photograph. The largest snowcapped peak rising above the forested foothills is Bachelor Butte, later renamed Mount Bachelor when it became a winter sports area in the late 1950s.

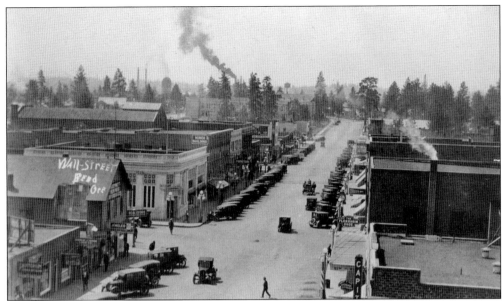

Automobiles and an occasional horse-drawn vehicle line busy Wall Street in this early 1920s photograph of Bend. The paving of streets in 1921 decreased dust and mud, but smoke still poured from the mills, which supported the city and its development, and from wood heating fires.

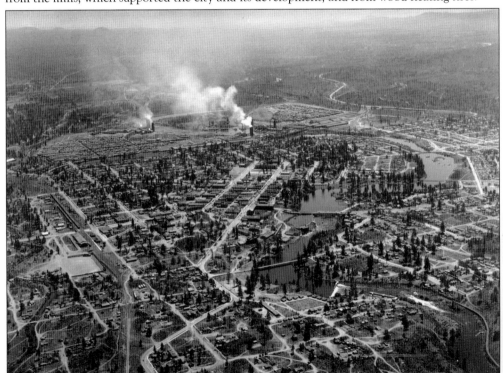

The Brooks-Scanlon mill (left) and the Shevlin-Hixon mill (right) puff smoke from their respective banks of the Deschutes River winding through Bend in this mid-1920s aerial view looking toward the southwest. In those days, smoke puffing from mills and factories meant progress and prosperity, not pollution.

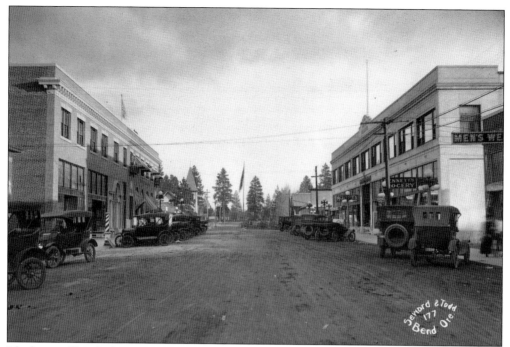

The heart of Bend's downtown business district in the late 1920s included Oregon Avenue between Wall Street and Bond Street. The First National Bank building is on the left, facing the O'Kane building on the right. The unpaved streets were soon to be a thing of the past.

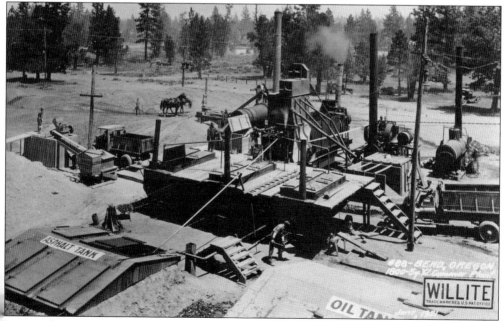

Paving of Bend's business district streets began on Wall Street near Franklin Avenue on May 28, 1921. The Willite Company mixed 800-pound batches of paving material at this plant south of the railroad depot and then transported it to paving locations.

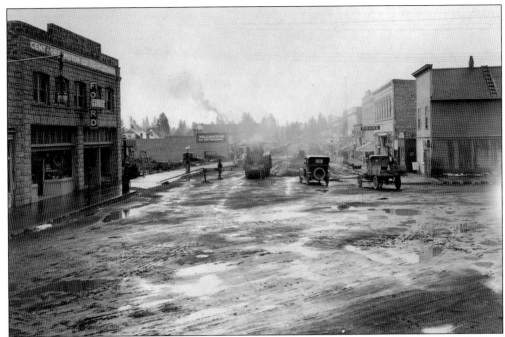

Willite Company paving proceeded on rain-soaked Bond Street in June 1921. Motor vehicles had largely replaced wagons drawn by horses and mules, and the Central Oregon Motor Company building on the left had replaced the Wenandy Livery Stable. Across the street, rooms were rented in the Meyers and Wilkey building. The Downing Hotel is next door.

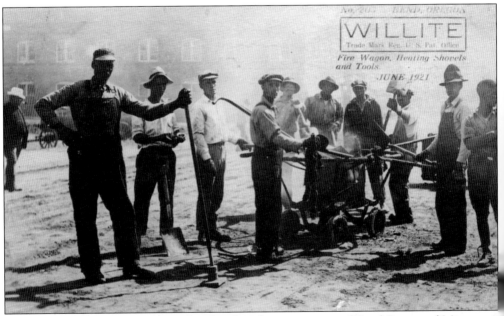

Willite Company paving workers take a break at the intersection of Bond Street and Minnesota Avenue in front of the Bend Hardware Company building in June 1921. Shovels and paving tools were heated over a fire wagon for use in smoothing the surface of the paving material.

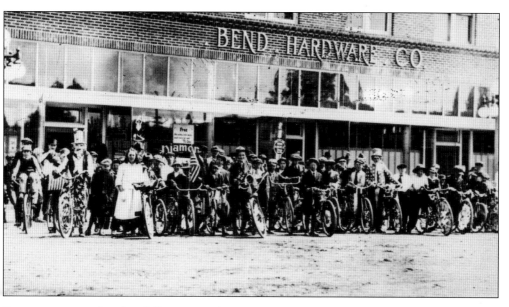

Street paving made a big difference to downtown Bend, as shown in these before and after paving photographs of the Bend Hardware Company building. In the before photograph (above), children in parade costumes line up on the unpaved Bond Street. In the after photograph (below), a smoothly paved Bond Street and Minnesota Avenue intersection is evident. This building, constructed in 1918, was occupied by the Bend Hardware Company until the business moved to the back of the building and became a wholesale supplier. In 1937, the George Childs Hardware Company moved into the front of the building to handle the retail hardware trade. Located at 850 NW Bond Street, this building was renovated early in the 21st century.

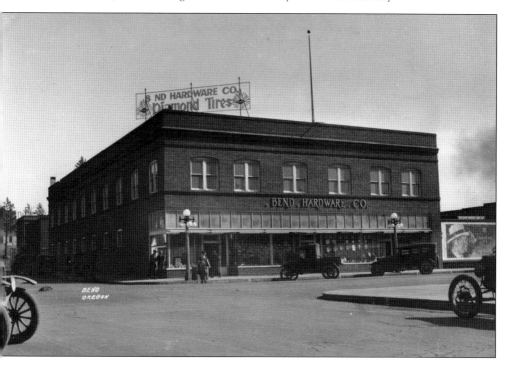

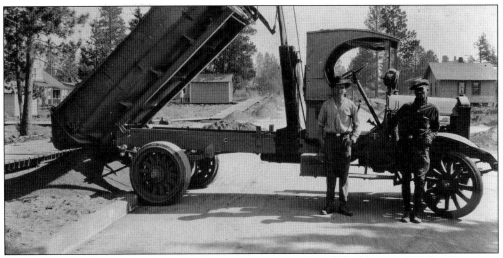

Paving was extended to some of Bend's residential streets. This solid rubber-tired Willite Company dump truck hauled paving material to Delaware Avenue during the 1921 paving project. The company's motto, "On Earth Foundation," referred to the process of paving directly on the surface without a layer of gravel as a foundation.

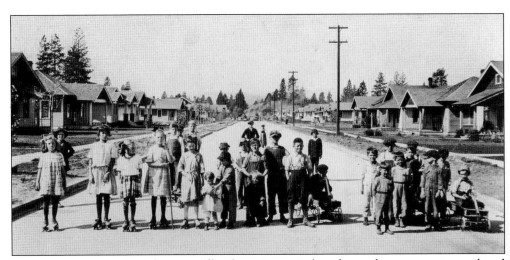

Bend's children—many of them on roller skates, some on bicycles, and some in wagons—loved the newly paved Delaware Avenue, shown in this September 1921 photograph, and the city's other newly paved streets. Bend was a great place to be a kid.

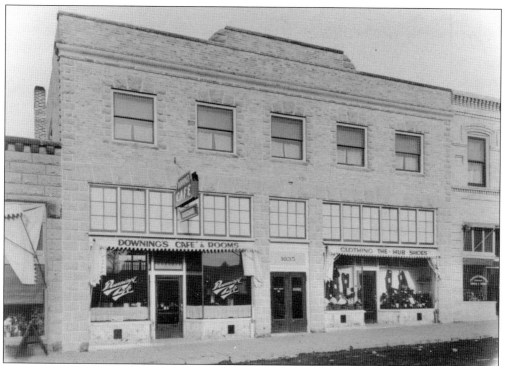

As Bend grew, more businesses catered to residents and travelers. This building at 1035 Bond Street, constructed in 1920, housed Downing's Café and Rooms, with 20 to 25 rooms on the second floor, and The Hub clothing and shoe store. The front facade was cut of native pink tuff stone and brick. The building has been recently restored.

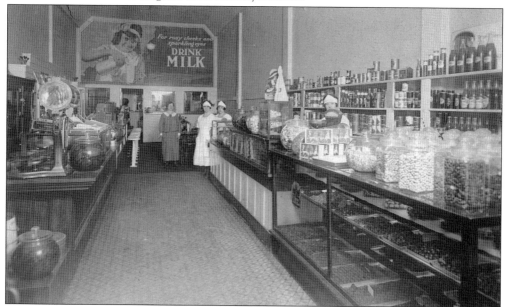

The Bend Dairy Store at 938 Wall Street, shown here in 1924, was a popular confectionary store that sold candy of all varieties and had a soda fountain in the rear. The ladies pictured are, from left to right, Mrs. Massart, Ms. Erma Blair, Ms. Hester Constibal, and Mrs. Frances Chapman.

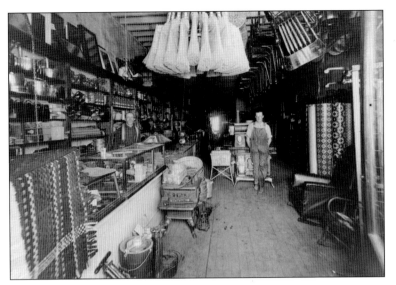

This early 1920s inside view of Stevenson and Rainey Central Oregon Store, at 956 Bond Street, shows the range of goods stocked by proprietors Samuel Stevenson and Henry Rainey. Household items displayed include brooms and chairs hanging from the ceiling and an ice cream maker sitting on the floor.

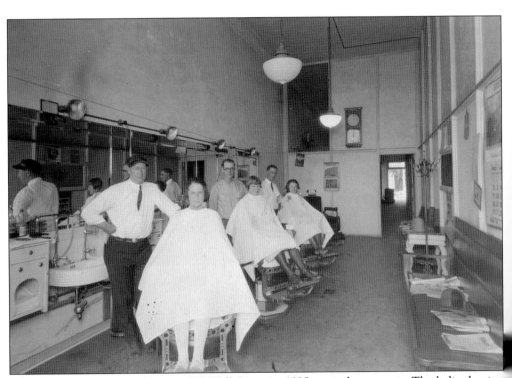

Slate's Barber and Beauty Shop at 825 Wall Street in 1925 catered to women. The ladies having their hair trimmed from left to right are Kathryn Carlon Matson, Esther Erickson Kelley, and Mrs. Stanley Scott. The barbers from left to right are Beecher Slate, Sharon Moore, and Dick Culley.

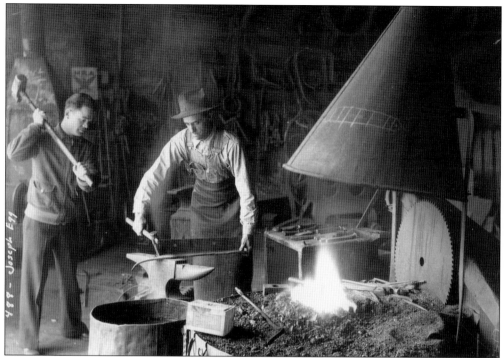

Joe Egg arrived in Bend in 1924, purchased Pete Pierson's blacksmith shop at 945 Harriman Street, and operated Joe Egg General Blacksmithing until the early 1970s. Joe is working at the anvil with Horrel Coulter in the above 1920s photograph. His business grew with the times. Outside Joe's shop, in the late 1930s, George Christopher parked the portable tie mill he built on a truck. With one or two men helping, he produced railroad ties from lodgepole pine in the La Pine area. The building once occupied by Joe's blacksmith shop is now a popular restaurant at 211 NW Greenwood Avenue.

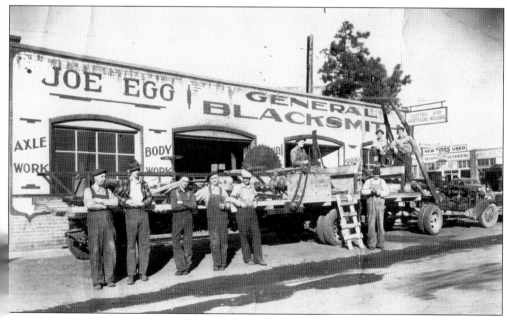

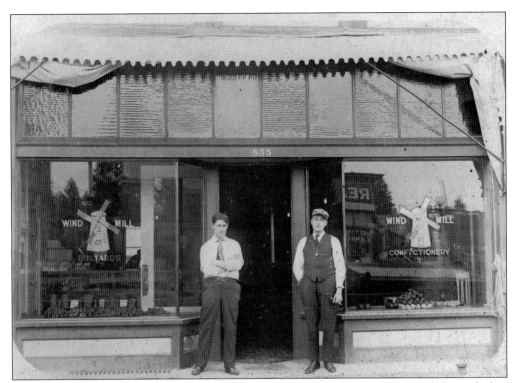

Charles A. Nickell (above, in cap) owned the Wind Mill Billiard Parlor at 855 Wall Street before World War I. He locked the doors to go to war. Nickell served in the U.S. Army's famed 42nd Infantry Division, the "Rainbow Division," and was wounded in action in France and decorated for bravery. Upon his return to Bend, he and his wife, Daisy, operated the Hippodrome at 645 Wall Street. Mill workers, loggers, and others enjoyed many evenings at the Wind Mill Billiard Parlor, shown here as it appeared in 1921.

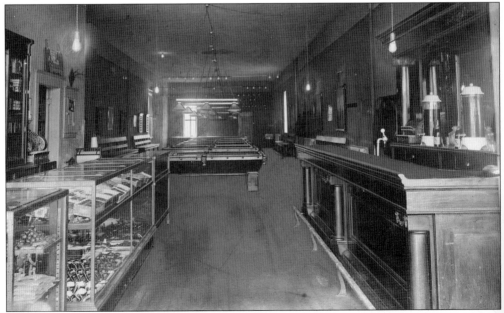

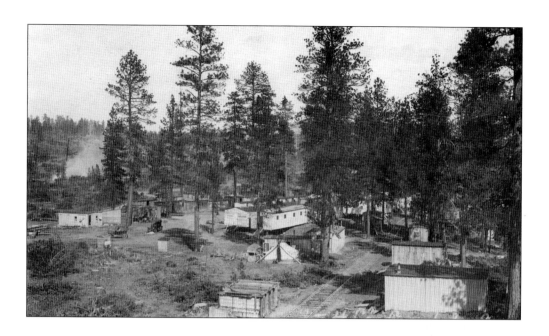

Mill workers and loggers were the lifeblood of Bend. While mill workers lived in town, many loggers lived in the forest at logging camps operated by the Shevlin-Hixon and Brooks-Scanlon companies. These camps provided separate cabins for families and bunk cars for single men. Many workers brought their automobiles to the camps and drove into Bend for supplies and entertainment. The photograph above shows Shevlin-Hixon Camp No. 9 about 1925. All the trees have been cut around the camp, but the trees in camp have been left for shade. These camps were portable, and when a particular area had been logged off, they were moved to another location. Cranes were used to load the cabins on flatbed railroad cars, which they were built to fit, for moving the camps from one location to another.

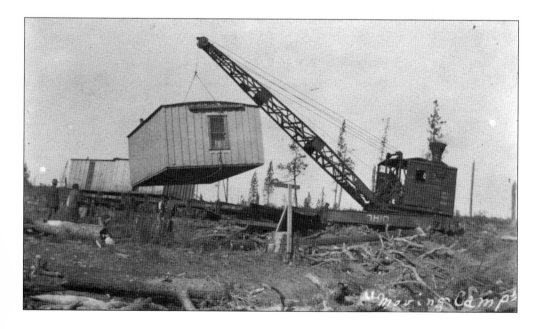

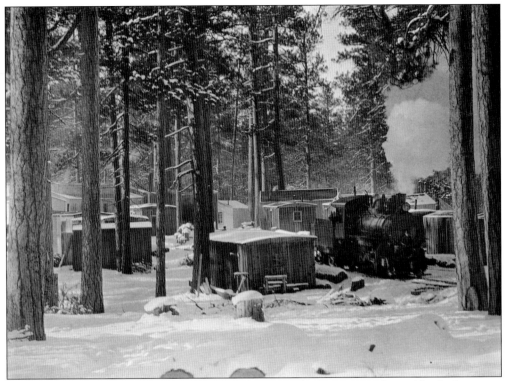

Railroad logging made these portable logging camps both necessary and possible. Such camps, which afforded the necessities of family life in company stores and even schools and churches, disappeared when railroad logging ended in the 1950s. In this wintertime photograph of a Brooks-Scanlon logging camp near Bend, the railroad engine is ready to haul logs or move the camp to its next location.

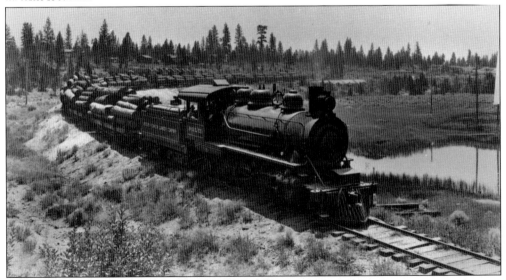

Once cut in the forest, yarded to a landing, and loaded on flatbed railroad cars, company logging trains such as this Brooks-Scanlon Company engine pulling over 20 flatbed cars loaded with logs rolled out of the forest on company tracks to the two giant mills in Bend.

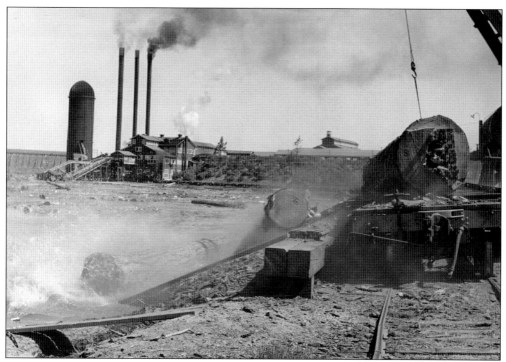

When log trains arrived at the Shevlin-Hixon and Brooks-Scanlon mills in Bend, the logs they carried were either dumped from the railroad cars into the millpond shared by the two companies, or piled onto a cold deck to await later dumping into the millpond en route to the saws. The Deschutes River was dammed to make a millpond for both mills. A separating log boom was built down the center of the pond. Logs bound for the Brooks-Scanlon mill were dumped east of the boom, and those bound for the Shevlin-Hixon mill went west of the boom. Both mills sawed their first logs in the spring of 1916. The dam is still in place, just below the Colorado Street Bridge. The flat places once occupied by the log decks are now parts of Bend's beautiful Farewell Bend Park.

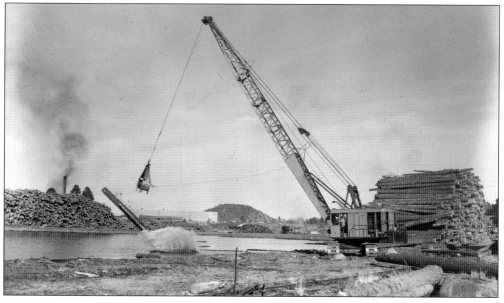

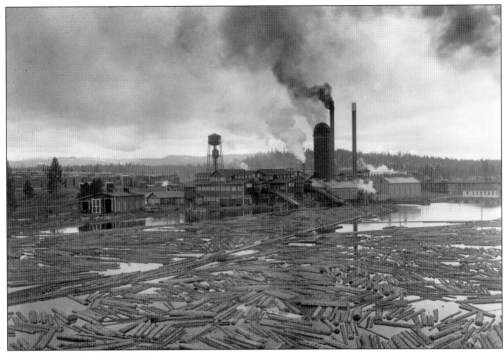

The Shevlin-Hixon mill on the western bank of the Deschutes River cut logs from its side of the millpond into dimension lumber that was stacked behind the mill to cure before being shipped to market. Nothing remains of the Shevlin-Hixon mill, which operated from 1916 until 1950. Today its site is occupied by a large brewery, an expansive office park, Riverside Park, and the Les Schwab Amphitheater.

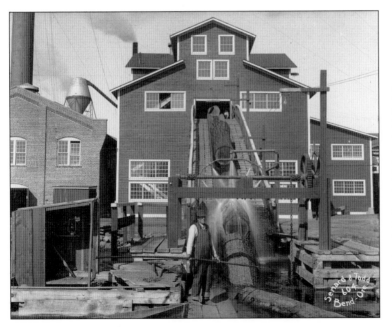

Logs from the millpond were pulled up a log slip, such as this one leading to the Brooks-Scanlon Mill A head rig to be sawed into lumber, stacked to cure, and shipped to market. The Mill A building still stands on the eastern bank of the Deschutes River overlooking the Colorado Street Bridge.

Both the Shevlin-Hixon and Brooks-Scanlon mills used head rigs such as this to saw large ponderosa pine logs into dimension lumber. Joe Francis, Brooks-Scanlon mill foreman (right), gives tail sawyer Bob Iverson a hand at letting down the wide board cut from this log by the band saw.

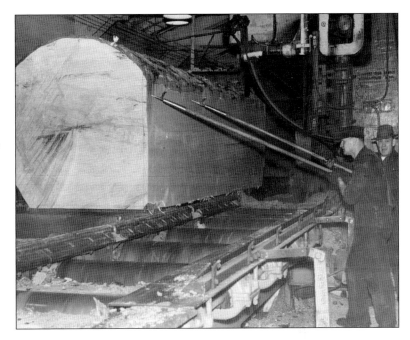

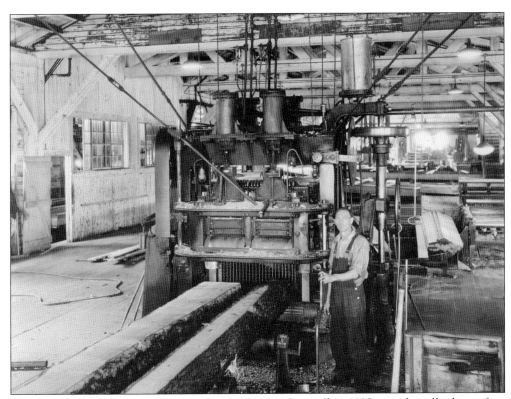

This gang saw, put into operation in the Brooks-Scanlon mill in 1925, sawed smaller logs, often of low quality, into lath for boxes or other low-grade products. The saw worked by moving a series of flat blades up and down as the log was pushed through the machine.

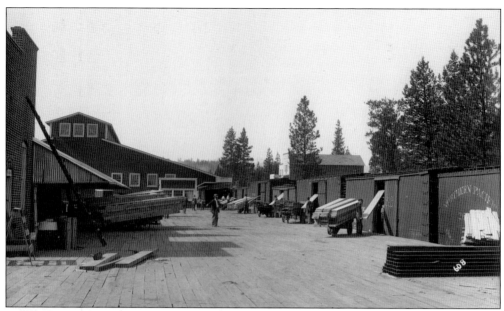

Finished and seasoned lumber was loaded into boxcars at the Brooks-Scanlon loading dock for transportation to market. The planing mill is on the right and the box factory is beyond. On the left is a hotel or boarding house where Arizona Avenue is now.

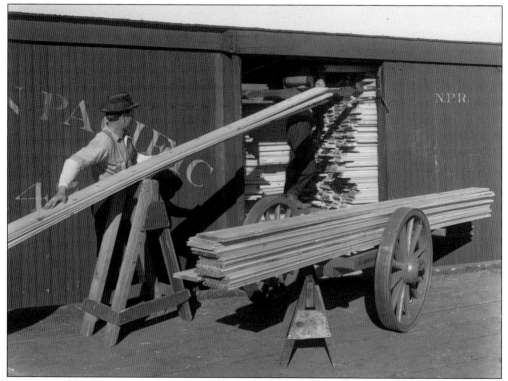

Loading lumber ready for shipment into boxcars was a laborious process. All boxcars were loaded by hand, one board at a time. This worker is loading high-value, tongue-and-groove, knotty-pine paneling.

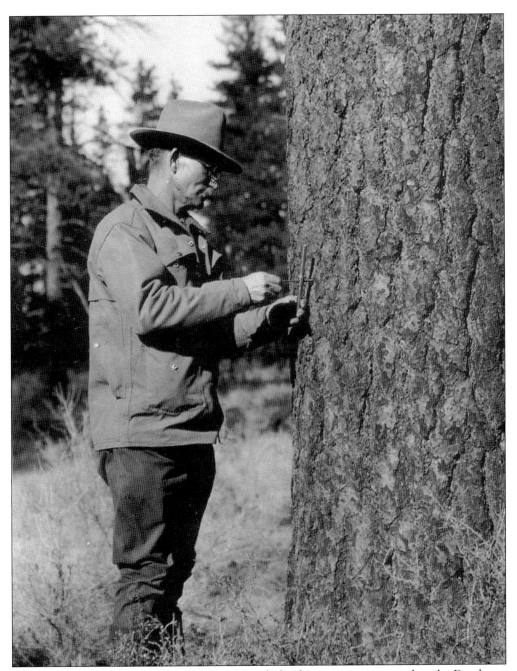

As their private timberlands were cut over, Bend's lumber companies turned to the Deschutes National Forest for trees to sustain their production and the city's economy. In 1925, the U.S. Forest Service transferred Walt Perry, a forester with a forward-looking timber management ethic, from the Carson National Forest in New Mexico to Bend. As "Chief Lumberman" on the Deschutes National Forest, he managed logging operations in the national forest. The General Exchange Act of 1922 allowed the companies to exchange their cutover timberlands, which were then incorporated into the national forest, for the opportunity to cut timber on the national forest under Forest Service supervision. (U.S. Forest Service, photograph by Carl B. Neal.)

Deschutes National Forest timberlands were harvested following scientific forest management methods that assured a sustained yield of timber for the future. Forester Walt Perry's management helped establish and maintain healthy second-growth ponderosa pine forests on national forest lands, as well as on previously private cutover lands. (Courtesy of U.S. Forest Service.)

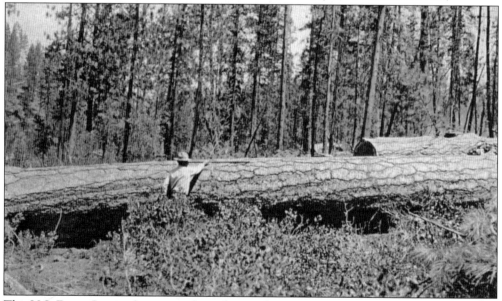

This U.S. Forest Service forester used a scaling stick to measure the volume in board feet of this large ponderosa pine, cut on the Deschutes National Forest, to be milled in Bend. (Courtesy of U.S. Forest Service.)

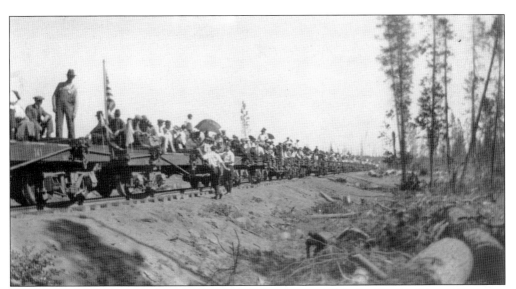

Logging and milling was a way of life in Bend. Starting in 1920, the Shevlin-Hixon Company sponsored an annual company picnic. Families rode to the picnic just upstream from Benham Falls, south of Bend, on the company railroad on the same flatbed cars used by the company to haul logs to the mill.

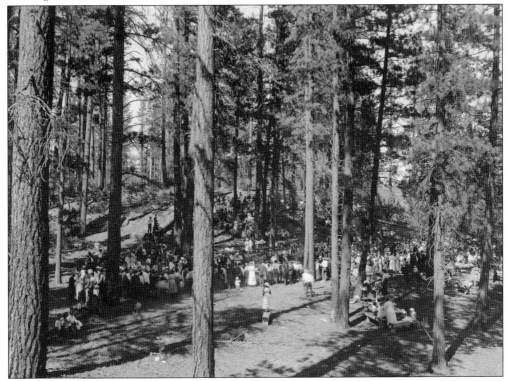

The annual Shevlin-Hixon Company picnic was held in a grove of large ponderosa pines at a bend in the Deschutes River about one-half mile south of Benham Falls. Because they shaded the picnic ground, these trees were not cut and remain on the site, now within the Deschutes National Forest.

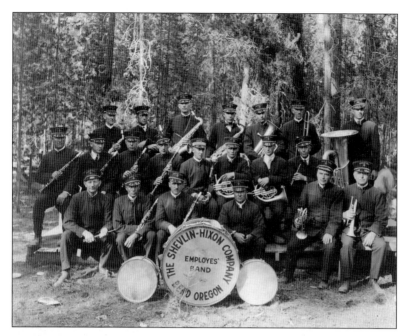

The Shevlin-Hixon Company Employees Band played at the annual company picnic and at many local events and parades. The band's lively music added an extra dimension to the quality of life in Bend during the early days.

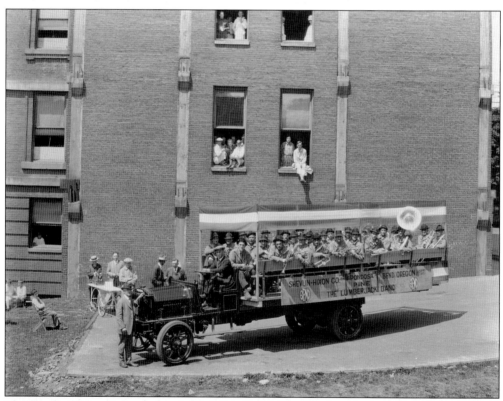

The Shevlin-Hixon Company Lumberjack Band helped put Bend on the map. In 1925, for example, it played at the Portland Rose Festival. On that trip the band also played at the Shriners Hospital and was featured on KGW Radio.

As timber boomed, agriculture benefited from farm-to-market roads. Oregon's Market Road Act of 1919 appropriated funds for development of market roads in the state's various counties. These roads were designed to carry goods from production centers to market centers. Existing roads were upgraded and new roads were built. Many were named for landowners living in the immediate area of the road. Over 50 market roads were developed in Deschutes County, and many of them served the Bend area. Butler Market Road, for example, was developed, in part, from the 1885 Powell Butte and Paulina Creek Road and was designated Butler Market Road in 1920. Deschutes Market Road was formerly the L. C. Young Road and was changed to Deschutes Market Road around 1929.

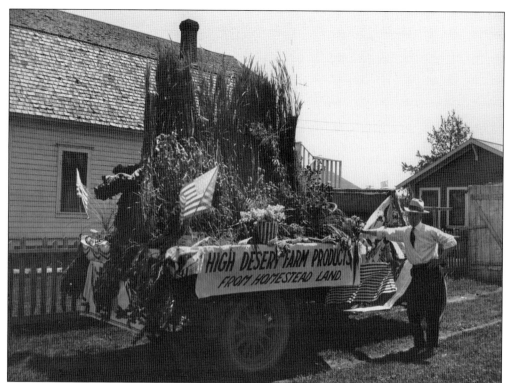

A wide variety of agricultural products was recognized for their contribution to the local economy. This float celebrating Central Oregon's many farm products took first place in Bend's 1921 Fourth of July parade.

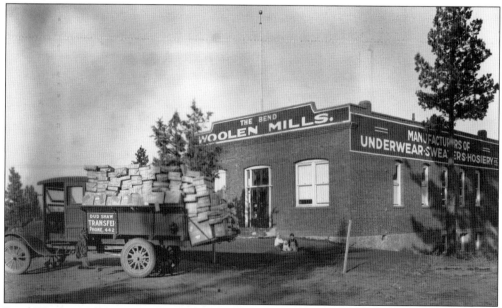

Bend Woolen Mills processed some of the wool shorn from the large herds of sheep that once grazed Central Oregon's rangelands and produced underwear, sweaters, hosiery, and other woolen products. Finished products are shown leaving the mill in Dud Shaw's truck.

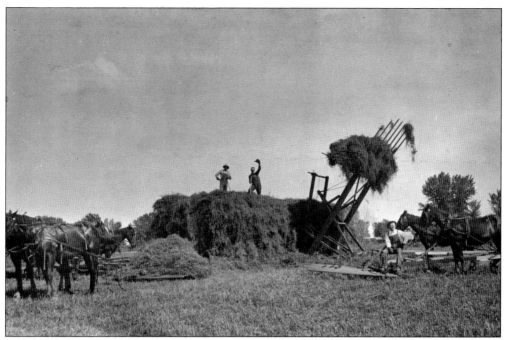

Building haystacks on Central Oregon farms and ranches required several teams of horses. The hay was loaded onto flats and then hauled to the side of the stack where a large fork was inserted under the pile. The fork was then pulled by a team on the near side of the stack.

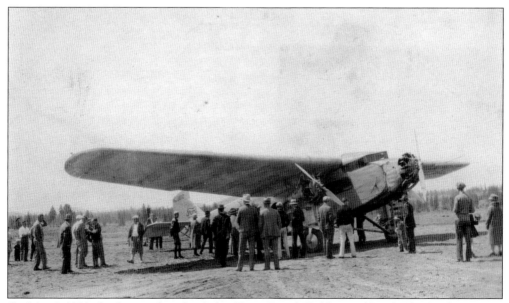

On May 8, 1920, the first airplane landed at Knott Ranch Field east of Bend. This Ford Tri-motor plane flew from Sunnyside, Washington, to Bend on June 8, 1929. The aircraft, named *West Wind*, could carry 14 passengers and a crew of six. The plane took short hops over Bend before flying on to Burns and Klamath Falls.

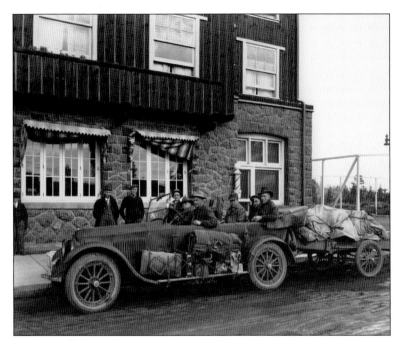

Bend was an early center for outdoor sports and recreation, much of which occurred on the surrounding Deschutes National Forest. On Wall Street, in front of the Pilot Butte Inn, this hunting party of five is about to set out in an open touring car in the 1920s. Both car and trailer were laden with camp gear and supplies.

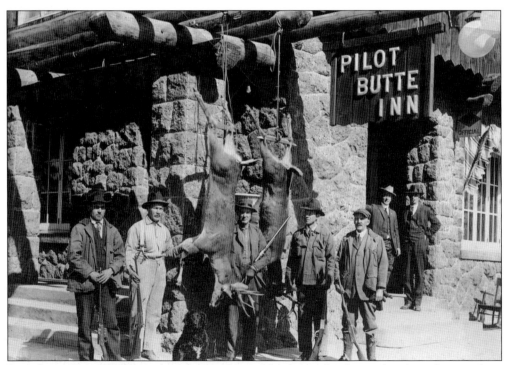

Back from a successful hunt, this hunting party of five hangs the deer it shot from the pergola at the Pilot Butte Inn for all to admire. Local men as well as visitors hunted for sport and meat.

SHERIFF HOLDS BOOZE FUNERAL

Eight Stills Destroyed, and 10 Gallons of Liquor Poured Out

The 18th Amendment to the U.S. Constitution, adopted by Congress in late 1917 and ratified by the states by early 1919, ushered in the Prohibition era during which the export, import, manufacture, or sale of alcoholic beverages was prohibited. Prohibition resulted from temperance agitators, moral and social reformers extolling the need to use grain for food rather than drink during World War I, and patriotic condemnation of persons of German descent prominent in the brewing and distilling industries. As attested by the clipping at right from the February 9, 1924, issue of the *Bend Bulletin* and the below photograph taken in front of the Deschutes County Jail, local law enforcement officials were kept busy dismantling stills used to produce illegal alcoholic beverages. Enactment of the 21st Amendment in 1933 repealed Prohibition.

Eight moonshine plants which have been collected by Sheriff S. E. Roberts and his deputies in recent months, were destroyed this morning and 10 gallons of moonshine liquor brought in by the officers was dumped in the gutter of the alley in front of the jail, flowing in a yellow stream to Oregon avenue.

Sheriff Roberts has more confiscated liquor in the county jail, but he plans to invite representatives of the W. C. T. U. to witness its destruction—or to take a hand in destroying it, if they like.

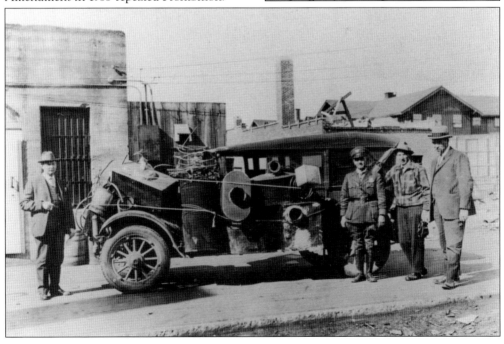

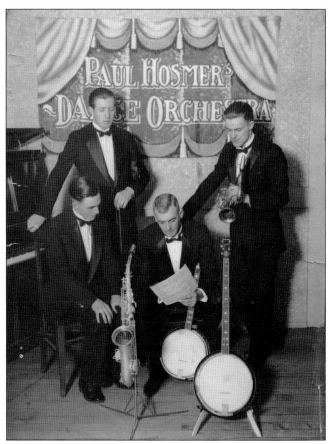

Social life in Bend survived Prohibition. Paul Hosmer's Dance Orchestra (left), with Paul Hosmer on banjo and Hugh Amsberry on sax and banjo, played at such venues as The Hippodrome. This brick building (below), constructed at 645 Wall Street on the southwest corner of Wall Street and Louisiana Avenue, opened in 1916 and served as a dance hall and skating rink until 1941 when it was sold to the Safeway grocery store chain. A hippodrome in ancient Greece was an open area for horse and chariot races. The term came to refer to a place of amusement or entertainment.

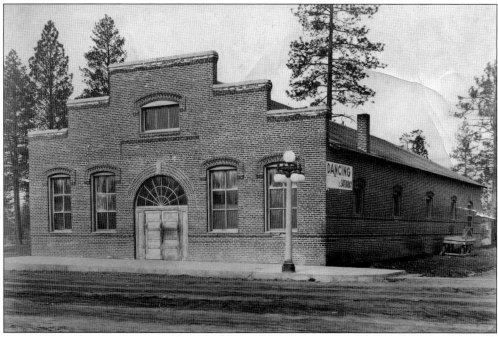

Five

SURVIVING THE
HARD TIMES
1928–1945

The Great Depression struck in September 1929, but for Pacific Northwest timber towns the first signs of economic trouble were visible as early as 1928. Lumber mills manufactured building materials, but people out of work did not build new houses. Lumber production declined in 1928 and then plummeted in 1929 and 1930. Bend's two big mills kept running, but production dropped significantly. The mills helped their workers by staggering logging and manufacturing schedules so everyone received some work during the bleakest months.

Workers who were unemployed, or marginally employed, were not able to afford much entertainment. Families attended school games and functions. Memberships in social clubs like the Odd Fellows grew. Outdoor recreation, including hiking, skiing, and camping, became popular. The Bend Skyliners built their lodge on Tumalo Creek in 1936. Deschutes National Forest supervisor Cleon Clark had trained as an architect at the University of Oregon and prepared a pleasing design for the rustic lodge.

Franklin Delano Roosevelt was elected president in 1932, and the "New Deal" began. The Civilian Conservation Corps (CCC) established a camp at Pringle Falls, and the CCC worked on conservation and construction projects in the Deschutes National Forest until 1941. In Bend, the Works Progress Administration (WPA) built the downtown post office and the Deschutes County Courthouse. The National Recovery Administration (NRA) regulated lumber industry wages and prices from 1935 to 1937. Many of the NRA programs were unpopular with workers and mill owners, but they helped stabilize the industry. By the end of the decade, Bend mills were running and new mills were being built in Gilchrist, Prineville, Redmond, and Sisters.

The United States entered World War II in December 1941. Bend mills produced lumber for the war, and employment rose above pre-Depression levels. Workers were hard to find because many young men enlisted in the armed forces and older workers moved to the Portland shipyards for higher wages. The army established Camp Abbot south of Bend where soldiers trained as combat engineers. On the weekends they flocked to Bend for rest and recreation at movies, restaurants, and dances.

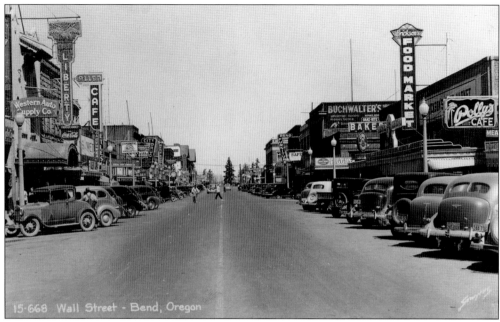

Most of Bend's businesses in the 1930s—auto supply shops, garages, grocery stores, cafes, and theaters—were located within the downtown area. Wall Street, shown here, was also the route of The Dalles-California Highway, now mostly referred to as U.S. Highway 97, the main north-south highway through Central Oregon.

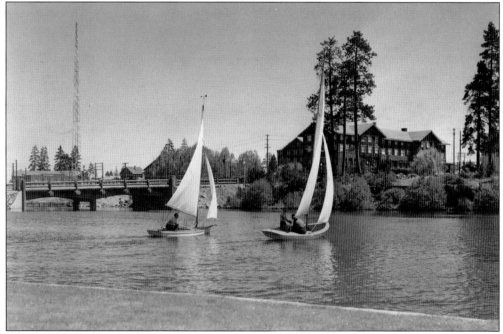

Just a block west of Wall Street, the Newport Avenue Bridge provided access to northwestern Bend residential areas and the Deschutes River provided a sylvan setting for the Pilot Butte Inn at 1101 NW Wall Street. Radio station KBND erected the 175-foot tower visible behind the bridge in November 1938 and began broadcasting the following month.

Also just west of Wall Street, and within easy walking distance of downtown Bend, fashionable residential districts had been built on the eastern and western flanks of Mirror Pond. Swans have been synonymous with and symbolic of Mirror Pond since a pair known as Clyde and Leila were introduced in 1929. The swans were named for local personalities Clyde McKay, who was Kiwanis Club president at the time, and Liela Schwendker, a pianist. McKay was involved in countless local activities and enterprises, especially those he believed would promote Bend's growth. He was instrumental in acquiring the land that became Drake Park.

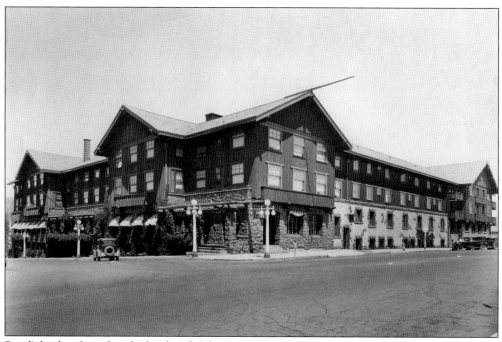

Bend's leading hostelry, the landmark Pilot Butte Inn on the northwest corner of Wall Street and Newport Avenue, was expanded during the 1930s from 60 to 150 guest rooms. A main attraction was the dining-room window, which was 16 feet long, 6.5 feet high, and framed a beautiful view of snowy Cascade Range peaks. During its heyday, the hotel attracted many well-known personalities including Pres. Herbert Hoover, First Lady Eleanor Roosevelt, and Sen.—and later presidential candidate— Thomas Dewey. Hollywood notables who stayed there included Nelson Eddy, Ray Milland, and Marlene Dietrich. It fell on hard economic times in the 1950s and 1960s, was closed to the public in 1965, and razed in 1973.

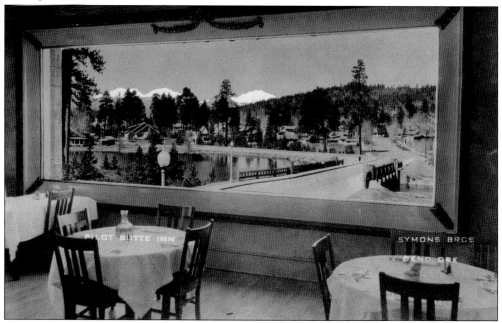

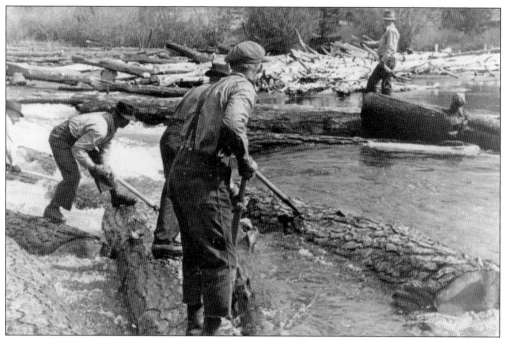

The lumber industry remained the backbone of Bend's economy. These loggers used peaveys to dislodge the logs in a river drive down the Deschutes River. Log driving was not a common practice in Central Oregon, but it was used to get the timber out of the area along the Deschutes River that was to be flooded by construction of the Wickiup Dam.

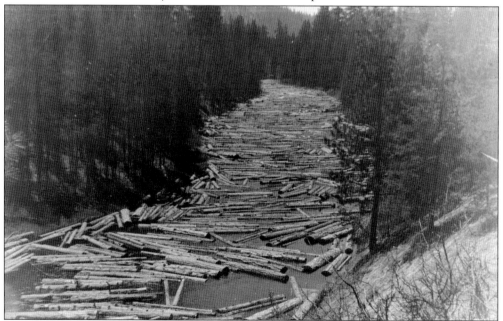

In 1939, the Shevlin-Hixon Company conducted a major Deschutes River log drive. The logs were floated some 40 miles to the slack water above Benham Falls, where they were corralled and loaded onto flatbed railroad cars. An estimated 26 million board feet of timber was moved during this drive.

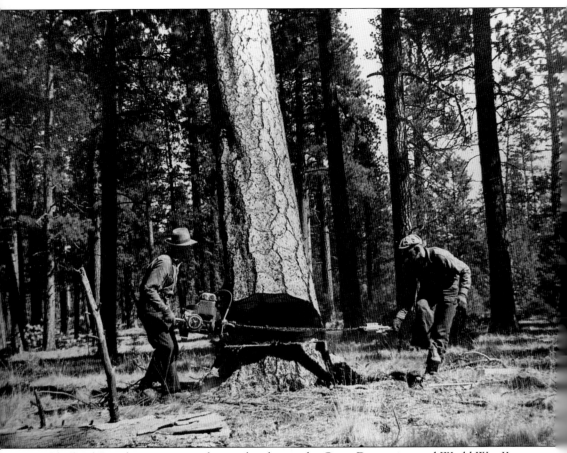

The lumber industry continued to evolve during the Great Depression and World War II years. The replacement of "misery whips" by power saws, for example, was a major change. In 1943, the Brooks-Scanlon Company began using power saws, first for bucking tree trunks into logs and later for felling trees. Here timber fallers use a two-man power saw to cut a ponderosa pine.

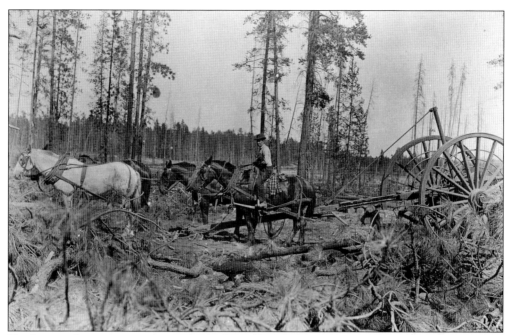

Hay-burners began to give way to internal combustion engine–powered machines. John Franks high-wheeled with a four-horse team for Daddy Rice of the Shevlin-Hixon Company in 1921. Horses were used in the woods until the mid-1940s and in the lumberyards to haul carts loaded with dimension lumber until the mid-1950s.

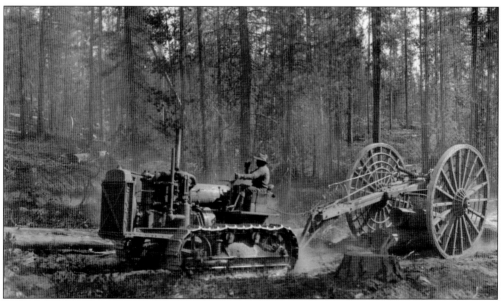

High wheels, once pulled by horses, were being pulled by tractors in 1940. The high wheels frequently were being reinforced with metal plates to withstand the extra stress of the powered equipment. Today high wheels are found only in parks—such as Drake Park in Bend—and logging museums.

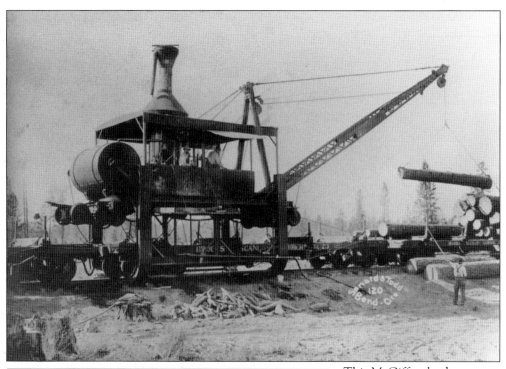

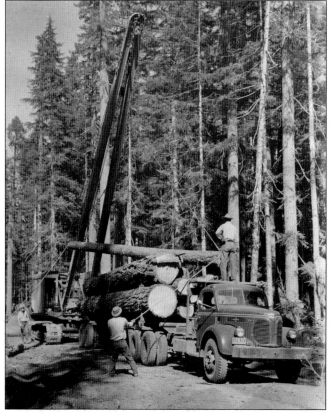

This McGiffert loader was used by the Shevlin-Hixon Company to load cut logs onto flatbed railroad cars for transportation to the company's mill in Bend. The steam-powered McGiffert loader could move on the tracks under its own power.

By the 1940s, timber-harvesting equipment began to change. Tracked loaders such as this lifted logs onto trucks that eventually replaced railroad transportation to the mills. By the mid-1950s, the Shevlin-Hixon and Brooks-Scanlon logging railroads were a thing of the past.

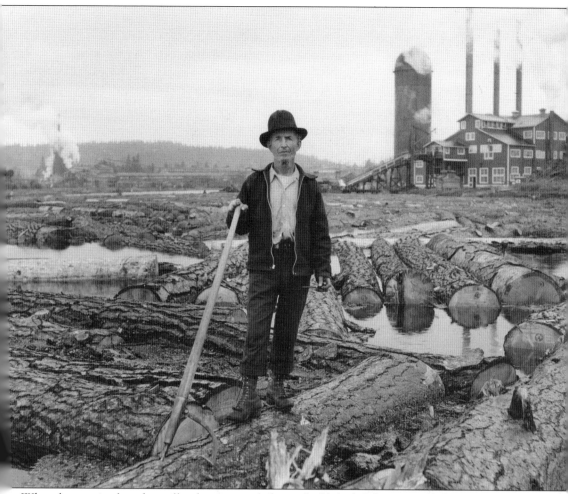

When logs arrived at the mills, they were piled into "cold decks" for eventual floating to the mill or dumped directly into the millpond for more immediate cutting as were these Brooks-Scanlon Company logs. One of the most agile workers at the sawmill was the "pond monkey," who managed the floating logs on the pond. Dan McLennan, photographed here upriver from the Brooks-Scanlon mills in 1935, was one of these. Wearing calk boots to walk on the floating logs, the pond monkey sorted and guided the logs from the log deck or log dump. The peavey and pike pole—used to keep the logs from hanging up on the way to the bull chain and up the slip into the mill—were the tools of his trade.

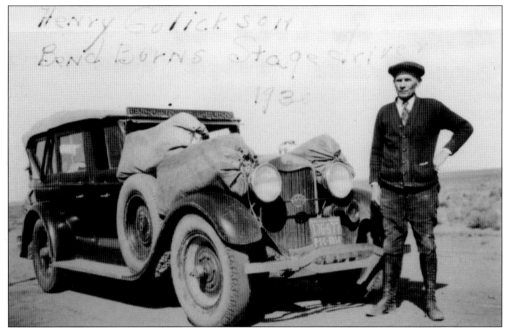

The advent and ascent of the automobile made its mark on both private and public transportation in Bend and throughout Central Oregon. In this 1930 photograph, Henry Gulickson, driver of the Bend-to-Burns stage, is ready for another trip.

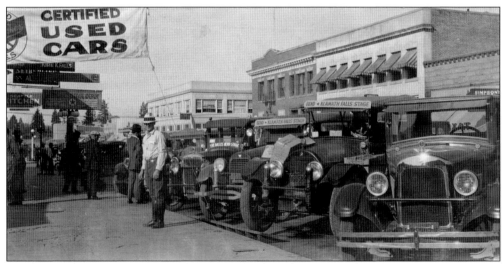

Automobile stage service was available in Bend as early as 1905. Eight stage lines were listed in the 1924–1925 city directory when the fare to Prineville was $1.75 and the ride to Burns cost $10.50. The southeast corner of Bond Street and Greenwood Avenue was the usual departure and return point. In this 1930s photograph, the Bend-to-The Dalles stage and the Bend-to-Klamath Falls stage await departure.

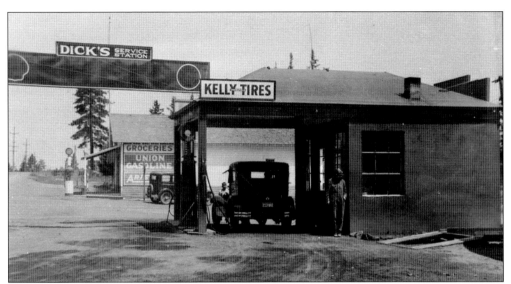

The fact that private automobile transportation had come into its own was reflected throughout Bend by service stations and garages. This car is being filled up in Bend at Dick's Service Station next to the Vellum Store at the corner of First Street and Revere Avenue in the 1930s.

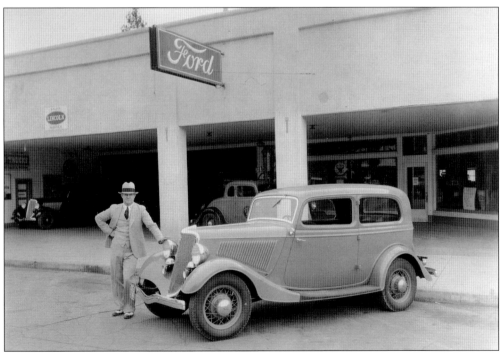

William Van Allen, manager of Houk Motor Company, a Ford dealership at 61 Oregon Avenue in Bend, shows off a new 1934 Ford sedan. After growing up in Redmond, Oregon, Van Allen graduated from Oregon State College, worked for Standard Oil Company in Redmond as a bookkeeper, and then joined Houk Motor Company, which he managed until the business was sold. He then opened and managed the Houk-Van Allen Firestone store. He became a writer and photographer and taught photography at Central Oregon Community College.

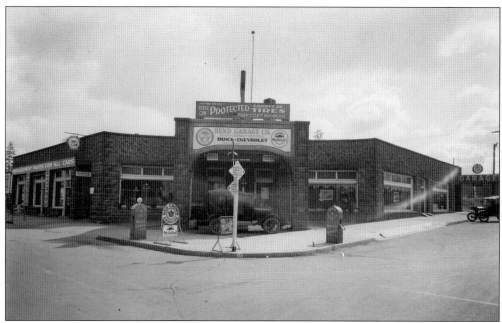

A stone garage constructed on the corner of Wall Street and Greenwood Avenue in 1923 by Dr. J. C. Vandevert and O. M. Whittington housed two Bend automobile dealerships and played a role in World War II. Walter G. Coombs, who established the Bend Garage in 1916, rented the building in 1924 to sell Chevrolets and Buicks and operate a service station. Edwin Walter "Eddie" Williamson purchased the property in 1936 and established Eddie's Sales and Service as a Chrysler dealer. Williamson added to the building and, during World War II, it served as a supply depot for the U.S. Army's training center at Camp Abbot, south of Bend. Williamson rebuilt it after the structure burned in 1948 and operated the business until the late 1970s. In 1990, the Williamson family leased the property to the Bank of the Cascades. The stone arch and columns of the gas station were incorporated into a new bank building that bears the name "Eddie's Corner."

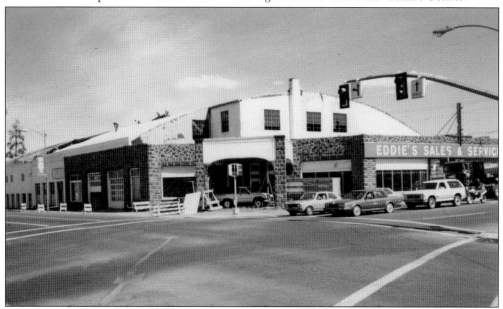

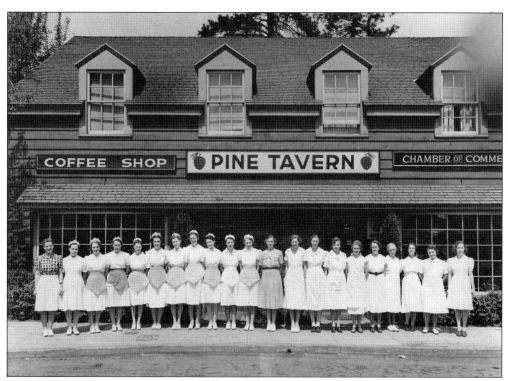

Proprietor Maren Gribskov opened the Pine Tavern in December 1936. Maren and Martha Bechen arrived in Bend in 1919 and opened the OIC Cafeteria on the west side of Bond Street. Martha married Sid Conklin in 1936 and left the business that year. After several location changes, the OIC Cafeteria closed with the opening of the Pine Tavern. Maren operated the Pine Tavern until 1967. This fine restaurant remains a tradition for locals and visitors.

The Pine Tavern has always been known for its delicious food, and its 1940s-menu is a nostalgia trip. To make its fare available everywhere, Maren Bribskov and Eileen Donaldson published *Maren's Pine Tavern Menus and Recipes*, which was in its 10th printing in 2003.

Coffee Shop

CLUB BREAKFASTS

MIDDAY LUNCHEONS

DINNERS

ALSO

A LA CARTE SERVICE

OPEN 7 A.M. TO 10 P.M. DAILY
CLOSED SUNDAYS

Pine Dining Room

| Luncheon | 12:00 | 2:00 |
| Evening Dinners | 6:00 | 9:30 |

All prices listed are at or below our ceiling prices. By OPA regulation, our ceilings are highest prices from April 4, 1943 to April 10, 1943. Records of these prices are available for your inspection.

FOUNTAIN SERVICE

Ice Cream	.10	Ice Cream Sodas	.15
Ice Cream Sundaes	.15	Milk Shakes	.15
Parfaits	.20	Malted Milks	.20
	Fresh Fruit Sundaes	.25	
	Iced Drinks		

APPETIZERS

Half Grapefruit	.20	Sea Food Cocktail	.35
Fresh Oyster Cocktail	.45	Fruit Cocktail	.15
Fresh Crab Cocktail	.35	Soups	.10
	Cream Soups	.15	

SANDWICHES

Sliced Chicken	.30	Hamburger	.20
Baked Ham	.30	Peanut Butter	.20
Tuna Fish	.30	Cheese	.20
Cold Meat	.25	Chicken Salad	.30
Bacon and Egg	.30	Lettuce	.15
	Tomato and Bacon	.30	

SALADS

Pine Tavern Salad Bowl	.30	Chicken	.50
Fruit Salad Bowl	.50	Crab or Shrimp	.60
	Pineapple Cottage Cheese	.50	

PIES—CAKES

| Home Made Pies and Cakes | .15 |
| A La Mode or with Cheese—.05 Extra | |

BEVERAGES

Tea—Per Pot	.10	Buttermilk	.05
Coffee	.10	Chocolate	.10
Milk	.05	Postum	.10
	Iced Tea	.10	

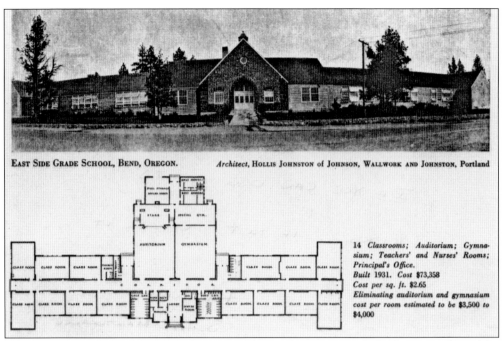

EAST SIDE GRADE SCHOOL, BEND, OREGON. *Architect, HOLLIS JOHNSTON of JOHNSON, WALLWORK AND JOHNSTON, Portland*

14 Classrooms; Auditorium; Gymnasium; Teachers' and Nurses' Rooms; Principal's Office.
Built 1931. Cost $73,358
Cost per sq. ft. $2.65
Eliminating auditorium and gymnasium cost per room estimated to be $3,500 to $4,000

The Allen Elementary School opened in 1931 at the northeast corner of Third Street and Franklin Avenue and was used until it was destroyed by fire in December 1963. The site is now occupied by a Safeway supermarket.

These young scholars are members of grades 7A and 8B and are posing at the Allen School on May 28, 1936. Among them is Pat Metke, son of famous Central Oregon log cabin builder Luther Metke. Mr. Lehman is the teacher (back left).

From left to right, Wilma Munkres, Donna Werner, Esther Reid, Edna Ives, Betty Jo Terwilligar, and Lillian Davis perform in the Allen School's 1938 May Day program.

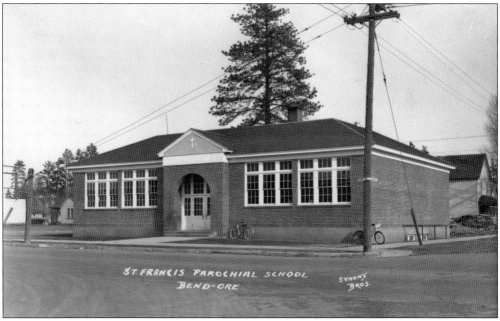

Private and parochial schools have served Bend for over 70 years. Prominent among them, and perhaps the oldest, is St. Francis School, which opened in this building at 720 NW Bond Street in 1936 with 129 students. The building was vacated in December 2001 when the school moved to its new campus on NE 27th Street. It is now part of the McMenamins Old St. Francis School restaurant and hotel complex.

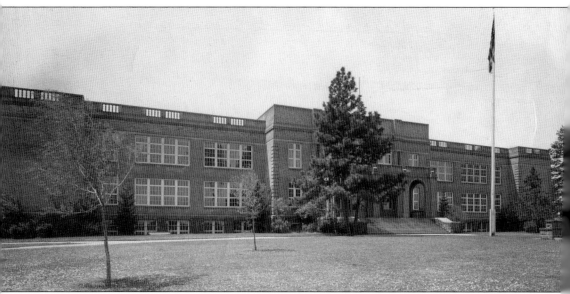

This building at 530 NW Wall Street housed Bend High School for 30 years from 1926 until 1956 when the new Bend High School at 230 NE Sixth Street opened. The building's architect, Hugh M. Thompson, was a Bend High School graduate and is believed to have been the first architect to live and work in Bend. He also designed the 1930 addition to the Pilot Butte Inn. The primary contractor was Ed Brosterhous who, with his late brother George, had built the Reid School. Students survived the Great Depression, and many of its graduates served in the armed forces during World War II. Some high school boys too young to serve in the war served as fire lookouts and firefighters and in other capacities during this time of limited manpower. The first Central Oregon Community College classes were held in the building in 1949. In 1956, it housed Cascade Junior High School, serving grades seven through nine. The building now serves as the Bend-La Pine School District No. 1 Administration Building.

Churches, fraternal orders, and social clubs helped Bend keep the faith and weather depression and war. Constructed in 1920, this St. Francis of Assisi Catholic Church edifice at the corner of Franklin Avenue and Lava Road replaced the old school building purchased in 1909 for $75 and donated in order to be what pioneer Fr. Luke Sheehan called "the only Catholic building dedicated to God in this vast section" at the time.

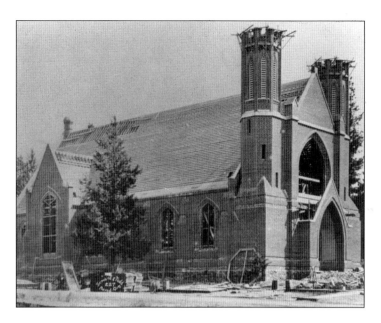

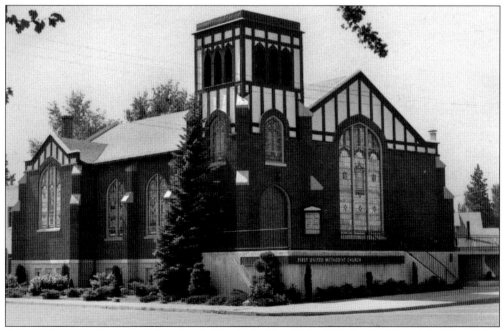

Among the many Protestant churches in Bend, the First United Methodist Church had its origins in Sunday services held as early as 1900 in Bend's early schoolhouses before it built its "Little Brown Church" at the corner of Franklin Avenue and Sisemore Street in 1912. The congregation soon outgrew that diminutive structure and moved into a new church building on the corner of Bond Street and Kansas Avenue where it remains.

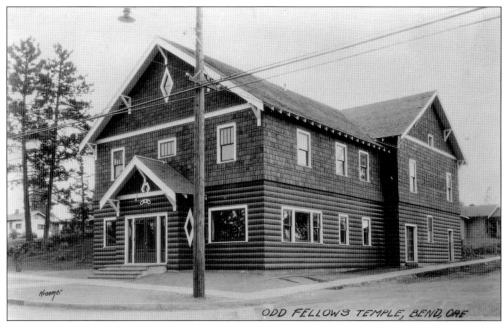

The Odd Fellows Temple at 265 NW Franklin Avenue, dedicated in November 1932, is typical of International Order of Odd Fellows (IOOF) halls found in many Oregon cities. This one has an unusual imitation milled by the Brooks-Scanlon Company. It has housed several denominations of churches and remains in use as office space.

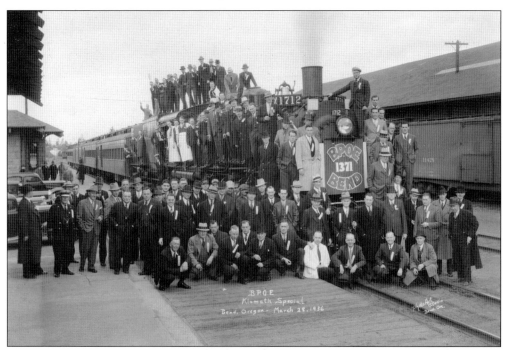

The Benevolent and Protective Order of Elks (BPOE) has been in Bend for many years. On March 28, 1936, this Bend BPOE Lodge 1371 delegation, led by Exhaulted Ruler Harry B. Leedy and including some 125 Elks, poses before leaving Bend's railroad depot on an excursion to Klamath Falls.

Sports also helped Bend get through the tough times. Scandinavians like Emil Nordeen (at right), who moved to Bend to work in the forests and mills, brought skiing and other winter sports with them. Enthusiasts organized the Skyliners in 1927 and established a ski area in the McKenzie Pass area. After several years, the Skyliners relocated to a site 8 miles west of Bend along Tumalo Creek where they built a ski lodge in 1936. Local skiers (below) Jim Hosmer, Bill Bowes, Jim McGee, Phil Peoples, and Sam Peoples enjoy a sunny Central Oregon skiing day in 1948. A lack of snow during the winter of 1956–1957 turned skiers' attention toward higher-elevation Bachelor Butte as the site of a ski area with more dependable snow. Mount Bachelor, Oregon's premier winter sports area, was the eventual result. Skyliner Lodge on Tumalo Creek remains in use as an organization camp and group event facility.

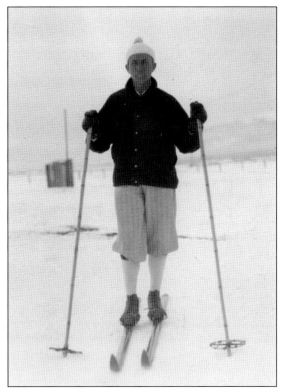

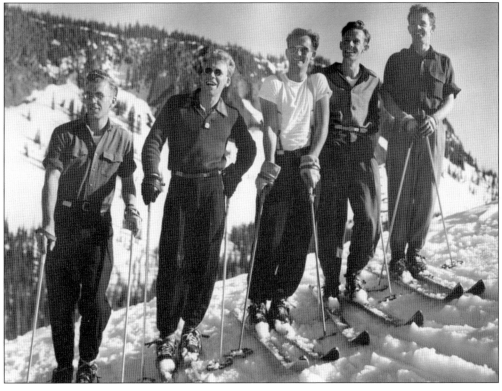

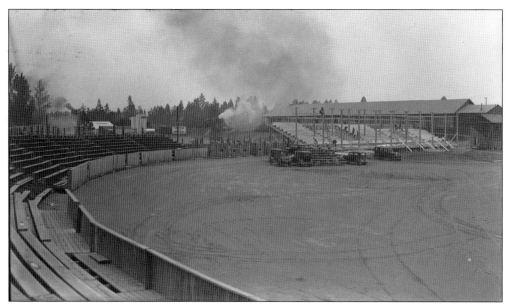

O'Donnell Field, north of Greenwood Avenue and east of the railroad tracks, was a venue for rodeos, the circus, baseball and football games, and other large-scale events. The grandstand, added in 1939, along with most of the bleachers, was destroyed by fire on July 8, 1943.

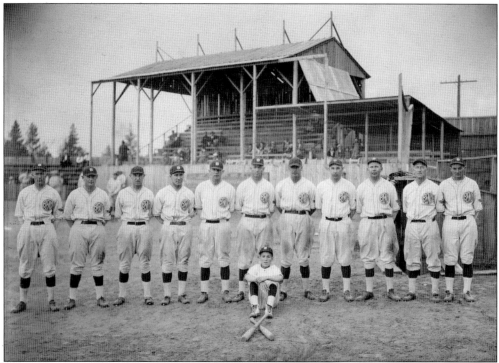

This 1930s baseball team helped satisfy Bend fans' craving for "America's pastime" at O'Donnell Field as the Bend Elks do now at Vince Genna Stadium. Bend has fielded many minor-league baseball teams over the years under such names as the Bucks, Bandits, and the current Elks. From 1992 to 1994, the Bend Rockies were a Colorado Rockies farm team.

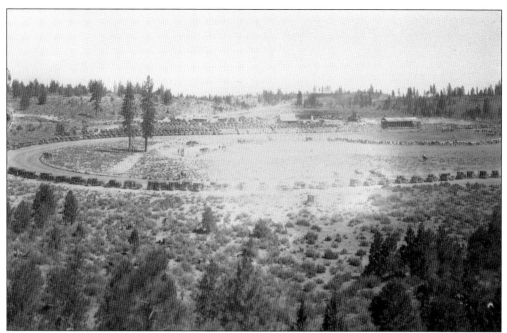

Rodeos were held at Bend's old brickyard before they moved to O'Donnell Field. The July 5, 1933, *Bend Bulletin* reported that "a crowd estimated at more than 5,000 people" attended the July 4 rodeo at the brickyard. "By the time the program of races and rodeo events began at 2 o'clock in the afternoon, more than 2,000 cars had rolled through the gates, the grandstands were filled to capacity. . . . It was the biggest crowd ever assembled for a rodeo in this part of the state."

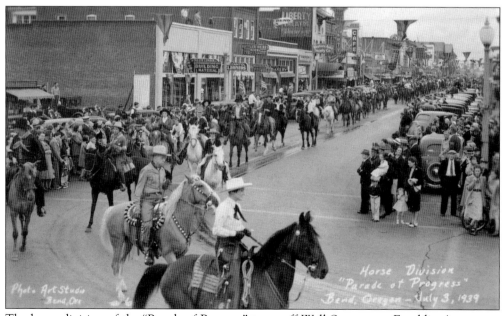

The horse division of the "Parade of Progress" turns off Wall Street onto Franklin Avenue on July 3, 1939. Bend's seventh-annual stampede, a two-day rodeo, took place at O'Donnell Field. The arena was one of the largest in the state.

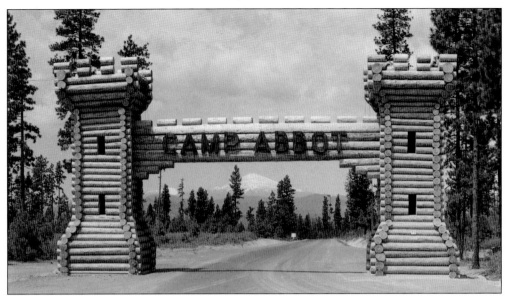

World War II brought the U.S. Army to Bend and Central Oregon. The main entrance to Camp Abbot, a 1943–1944 combat engineer training center on the Deschutes River, south of Bend, faced The Dalles-California Highway. Now called U.S. Highway 97, the route was later moved to its current location west of this site. The foundations of this gate are still visible on either side of Forest Road 9720. Sunriver occupies the Camp Abbot site. (Courtesy of U.S. Army Signal Corps.)

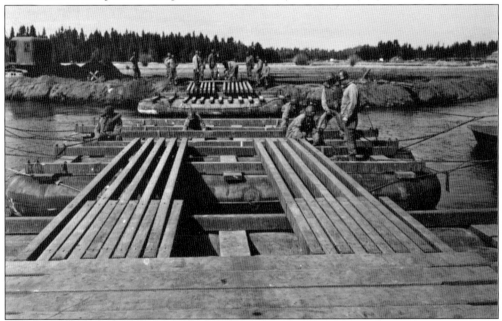

In addition to rigorous combat engineer training, Camp Abbot hosted the 1944 "Oregon Maneuvers" that tested the combat readiness of over 100,000 troops on 10,000 square miles between Bend and Burns. Bend provided civilian workers as well as service clubs and other home-front activities for Camp Abbot. Training staff was housed in seven buildings constructed in 1943 on NW Portland Avenue, now an apartment complex dubbed "Officers Quarters." (U.S. Army Signal Corps, photograph courtesy of Sunriver Nature Center.)

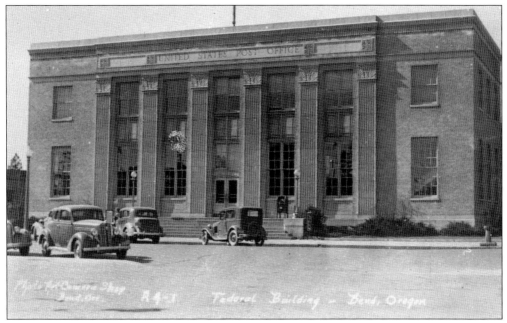

Construction of the Federal Building at 745 NW Wall Street, which housed the main Bend post office into the 1980s, began in 1932. This building also provided office space for other U.S. government offices, including the Deschutes National Forest supervisor's office.

Forest Supervisor Ralph Crawford (third from left) is photographed here in 1943 at Skyliner Lodge with members of his staff. They include, from left to right, District Ranger Henry Tonseth, Fort Rock Ranger District; District Ranger Harold Nyberg, Sisters Ranger District; District Ranger Homer Oft, Crescent Ranger District; Fire Control Officer Gail Baker; and District Ranger Joe Lammi, Bend Ranger District. (Courtesy of U.S. Forest Service.)

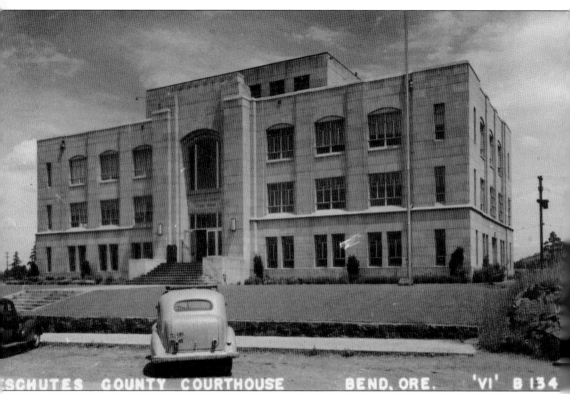

SCHUTES COUNTY COURTHOUSE BEND, ORE. 'VI' B 134

County officials pointed with pride to a rather unusual feature of the new fireproof Deschutes County Courthouse completed on December 31, 1941; built below budget, the structure at 1164 NW Bond Street was paid for at the time of completion. The building featured an elevator to the federally approved third-floor jail; convection-type radiators heated by a hogged furnace; special acoustical treatment of the big circuit courtroom; an attractive sandblast finish outside, with three coats of paint and two of sand; a concrete roof; asphalt floor tile; an air-conditioned courtroom; large offices with room for expansion; and a special assembly room for veterans organizations on the ground floor. For the first time in many years, most county business was conducted under one roof. At the building's dedication, a copper time capsule was laid in the cornerstone. The previous courthouse, east of this location, was destroyed by fire in February 1937.

Six

FROM THE MILLS TO RECREATION
1946–PRESENT

The post-war years brought prosperity to the lumber industry. Oregon had become the nation's leading producer in 1938 and held that position through the following decades. As the business was booming, however, the timber supply was diminishing. In 1950, Bend's Shevlin-Hixon mill was sold to Brooks-Scanlon and closed. In the following years, Brooks-Scanlon sold to Diamond International. A rapid succession of owners followed, and the old Brooks-Scanlon mill sawed its last log in 1995.

In the wake of the declining timber industry, recreation became Bend's leading business. Development of a ski area at Mount Bachelor began in the late 1950s, and skiing prospered into the 1990s. Then the ski area was sold to out-of-state investors and corporate headquarters moved to California. Today winter sports and summer outdoor recreation opportunities abound and continue to attract visitors year-round.

The destination resort business proved another success. In the early 1950s, the Hudspeth family of Prineville began plans for Sunriver, the area's first destination resort built on the site of Camp Abbot by developer John Gray. Other resort and residential communities followed, including Black Butte Ranch and The Inn of the Seventh Mountain. These offer year-round lodging and hospitality to visitors. Golf is especially popular.

As the 20th century closed and the 21st century dawned, Bend was "discovered" by a generation of Americans ready for retirement in a pleasant small town with good scenery and no visible social problems. Bend grew to almost 75,000 people by its 2005 centennial. Housing developments spread over the sagebrush plateau on Bend's east side and into the timbered hills on its west side. Construction and development emerged as the cornerstone of the local economy and the city's continuing growth.

Among the brighter spots on Bend's economic horizon are medical services. Bend has become a medical center for much of Oregon east of the Cascades. Physicians, nurses, and medical technicians bring stable positions with high salaries to the local economy. St. Charles Medical Center, one of the most sophisticated hospital and diagnostic facilities in Oregon, is Bend's largest employer. The hospital is ringed by general medicine and specialist clinics and doctors' offices.

Central Oregon Community College, also a leading employer, dates back to 1949 and is the oldest community college in the state. Academic programs offered by other Oregon colleges and universities since the 1980s, and the addition of Oregon State University's Cascade Campus in 2001, have vastly expanded Central Oregon's higher education opportunities.

By the 1950s, the city of almost 12,000 people had spread eastward to the base of Pilot Butte, as shown by this view looking west from Pilot Butte along Greenwood Avenue toward downtown Bend and Mount Bachelor, Broken Top Mountain, and the Three Sisters on the horizon.

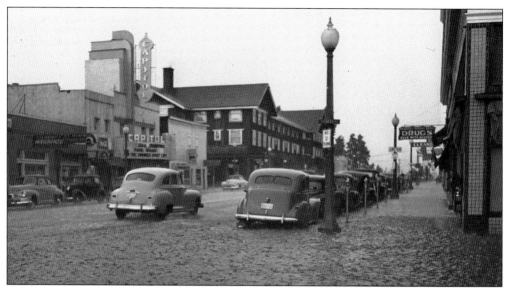

Downtown Bend in the 1950s, shown here during a thunderstorm that briefly flooded the intersection of Wall Street and Oregon Avenue, was dominated by the Pilot Butte Inn. Wall Street was the route of east-west U.S. Highway 20 as well as north-south U.S. Highway 97. *The Damned Don't Cry*, starring Joan Crawford and David Niven, played at the Capitol Theater.

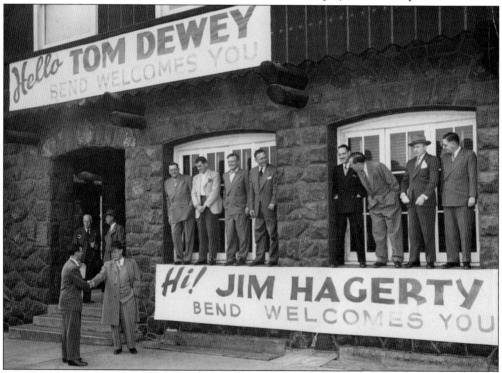

Bend welcomed Republican presidential candidate Gov. Thomas E. Dewey and other political and news personalities at the Pilot Butte Inn in 1948. In the doorway are Robert Sawyer (left), *Bend Bulletin* editor, and Duncan McKay (right), a local attorney and son of Clyde McKay. Pres. Harry S. Truman narrowly defeated Dewey in the 1948 election.

Bend City Hall, on the corner of Wall Street and Louisiana Avenue, housed Bend's city government from the time it was dedicated on May 1, 1939, until it was demolished and replaced by a new city hall on the same site. The brick-faced concrete building included a jail on its second floor.

Wetle's, a family-owned department store, opened in 1923 and advertised as "Bend's Economy Center, Dry Goods, Ready-to-Wear, Women's and Children's Shoes; John L. Wetle, Propreiter" and occupied this location from the mid-1930s until it closed in 1981. Even a serious fire in 1962 didn't stop the family business. For many years the Wetle's elevator was one of few in Bend.

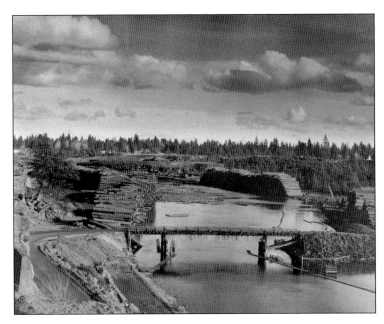

Lumber production remained Bend's principal industry into the 1960s. Massive "cold decks" of logs flanked the Deschutes River south of the Brooks-Scanlon Company mill. The bridge was built in 1957 to access the west side of the river where a new log dump was constructed for the Bend-Sisters truck road that replaced the rail lines to the west. Log trucking replaced the logging railroads in the 1950s.

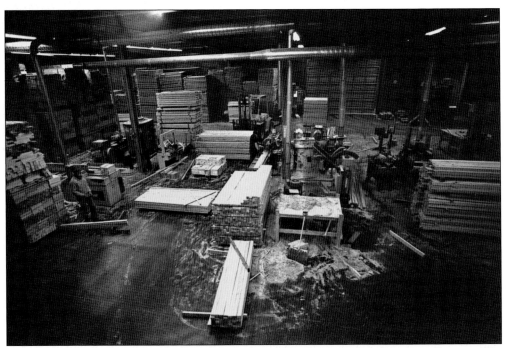

Bend's forest products industries included secondary wood manufacturing plants as well as sawmills. This 1984 photograph shows the interior of such a plant, which manufactured such wood products as molding, windows, and door frames.

Mirror Pond, on the Deschutes River just west of downtown Bend, was famous for its annual water pageants. *Bend Bulletin* writer Phil Brogan described the 1958 water pageant arch as "white as the Three Sisters that served as its backdrop." The water pageant queen, Carole Ann Mattson, rode through the arch on a huge swan, followed by four princesses of her court riding on cygnets. Floats in the water pageant that year told the story of the "Winning of the West."

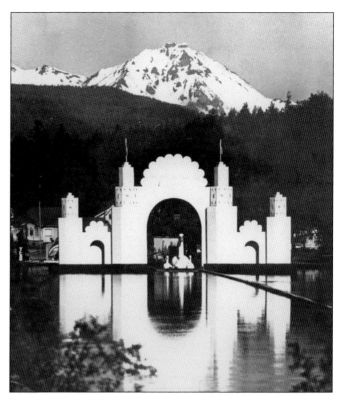

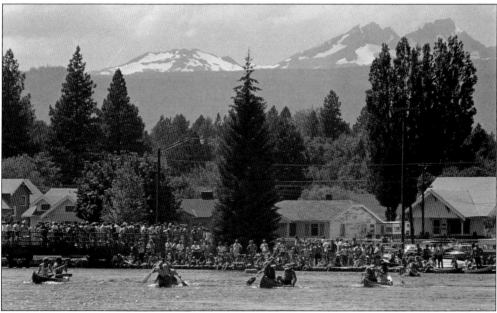

Mirror Pond has hosted innumerable water events over the years. These have included canoe races and, more recently, the paddle portion of the annual Pole, Pedal, Paddle Race, which begins with downhill and cross-country skiing events on Mount Bachelor, continues with a bicycle race down the Cascade Lakes Highway to the Deschutes River, and concludes with a canoe race and footrace to the finish line.

Bend's recent rapid growth occasioned expansion of its schools. One of Bend's new elementary schools, which opened in September 2004 at 2150 NE Daggett Lane, is named for Bend teacher Jack Ensworth, the 1973 National Teacher of the Year. First Lady Patricia Nixon presented the award to John Arthur "Jack" Ensworth at a Washington, D.C., ceremony. He taught at Kenwood Elementary School for 26 years and was representative of the high quality of education in Bend schools. Higher education arrived in Bend in 1949 with the establishment of Central Oregon Community College. By its 50th anniversary in 1999, over 4,000 students were enrolled. In fall 2001, Oregon State University opened its first branch campus—Cascades Campus—on the COCC campus in partnership with COCC as well as the University of Oregon and Eastern Oregon University.

Eighty years brought major change to Bend, Oregon. This 1924 aerial view shows the core area of the city when its population was about 8,000 and its economy was based on the lumber industry.

This 2004 aerial view shows the core area of Bend when its population approached 75,000 residents living in a city of a highly diversified economy in which the last sawmill had been closed for almost a decade.

BIBLIOGRAPHY

Barnes, Christine. *Central Oregon: View from the Middle.* Helena, MT: American and World Geographic Publishing, 1996.

Brogan, Phil F. *East of the Cascades.* Portland, OR: Binford and Mort, Publishers. 1971.

Coe, Urling C., M.D. *Frontier Doctor: Observations on Central Oregon and the Changing West.* New York, NY: The Macmillan Company, 1939.

Crowell, James L. *Frontier Publisher: A Romantic Review of George Palmer Putnam's Career at The Bend Bulletin, 1910–1914, with an Extended Epilogue.* Bend, OR: Deschutes County Historical Society, 2008.

Deschutes County Historical Society. *Bend, Oregon: 100 Years of History.* Bend, OR: Deschutes County Historical Society, 2004.

Gregory, Ronald L. *Life in Railroad Logging Camps of the Shevlin-Hixon Company, 1916–1950.* Corvallis, OR: Oregon State University Department of Anthropology, 2001.

Hatton, Raymond W. *Bend in Central Oregon.* Portland, OR: Binford and Mort Publishing, 1986.

———. *High Country of Central Oregon.* Portland, OR: Binford and Mort Publishing, 1987.

Joslin, Les. *Ponderosa Promise: A History of U.S. Forest Service Research in Central Oregon.* Portland, OR: U.S. Department of Agriculture, Forest Service, Pacific Northwest Research Station, 2007.

Perry, Walter J., ed. Les Joslin. *Walt Perry: An Early-Day Forest Ranger in New Mexico and Oregon.* Bend, OR: Wilderness Associates, 1999.

Riis, John. *Ranger Trails.* Richmond, VA: The Dietz Press, 1937. (Reprinted by Wilderness Associates, Bend, OR, in 2008.)

Sperof, Leon. *The Deschutes River Railroad War.* Portland, OR: Arnica Publishing, 2007.

St. John, Alan D. *Oregon's Dry Side: Exploring the East Side of the Cascade Crest.* Portland, OR: Timber Press, 2007.

Vaughan, Thomas, ed. *High & Mighty: Select Sketches about the Deschutes Country.* Portland, OR: Oregon Historical Society, 1981.

Williams, Elsie Horn. *The Bend Country: Past to Present.* Virginia Beach, VA: The Donning Company/Publishers, 1998.

ABOUT THE ORGANIZATION

The Deschutes County Historical Society
and Des Chutes Historical Museum
Bend, Oregon

The Deschutes County Historical Society, founded in 1975, and the Des Chutes Historical Museum, operated by the society, are located in the 1914 Reid School building at 129 NW Idaho Avenue—three blocks south of downtown between Wall Street and Bond Street—in Bend, Oregon.

The society exists to tell the story of Deschutes County, Oregon's last-formed county carved out of Crook County in 1916, and its communities in a way that excites and promotes appreciation, understanding, and preservation of their history. One of the many ways the society does that is by researching, writing, and publishing that history.

Another way is by operating the Des Chutes Historical Museum. Exhibits in this museum trace the county's history from ancient peoples who lived in the area up to 14,000 years ago, through more recent Native American peoples and European-American explorers and settlers, to even more recent timber industry workers and their families and ways of life during the early 20th century. Special events at the museum highlight aspects of this history.

And what about those two spellings of the name of the society and the museum—Deschutes and Des Chutes? The modern form Deschutes, used for the name of the county and the river that runs through it as well as for the national forest that covers much of it, is a simplified version of the name for the river known to early–19th century French fur traders as Riviere des Chutes or Riviere aux Chutes, meaning "river of the falls." As explained by Lewis A. McArthur and Lewis L. McArthur in *Oregon Geographic Names*, "The trappers applied their name because the river flowed into the Columbia River near the falls of that river and not because of any falls in the Deschutes itself."

DISCOVER THOUSANDS OF LOCAL HISTORY BOOKS FEATURING MILLIONS OF VINTAGE IMAGES

Arcadia Publishing, the leading local history publisher in the United States, is committed to making history accessible and meaningful through publishing books that celebrate and preserve the heritage of America's people and places.

Find more books like this at
www.arcadiapublishing.com

Search for your hometown history, your old stomping grounds, and even your favorite sports team.

Consistent with our mission to preserve history on a local level, this book was printed in South Carolina on American-made paper and manufactured entirely in the United States. Products carrying the accredited Forest Stewardship Council (FSC) label are printed on 100 percent FSC-certified paper.

MADE IN THE USA